Spirituality in Contemporary Art

Zidane Press

First published in the United Kingdom in 2010 by
Zidane Press Ltd
25 Shaftesbury Road
London N19 4QW

www.zidanepress.com

Design and layout by Velvet Design

Distributed by:
Turnaround Publisher Services Ltd
Unit 3
Olympia Trading Estate
London N2Z 6TZ
T: +44 (0)20 8829 3019

British Library Cataloguing in Publication data.
A catalogue record for this book is available from the British Library.

ISBN 978-0-9562678-3-2

The author would like to thank:
Professor Paul Coldwell, Richard Osborne, Dr Young sook Pak, Dr Zoe, Tillotson, Eileen
Cadman, and special thanks to my family Jae Hwan, Iyun ha, Sun Young, Young Joon for
their generous support.

Cover image: Antony Gormley, *Blind Light*, 2007
Hayward Gallery, London
© the artist, Photo: © by Stephen White, London

FADE
Fine Art Dgital Environment

 Zidane Press

Spirituality in Contemporary Art
The Idea of the Numinous

Jungu Yoon

Contents

Introduction

Chapter 1

Religion and Spirituality: A Brief Historical Survey

1.1 Artistic Expression at Different Stages of Religious Evolution
1.2 The Artist as Anti-Christ? Ofili, Serrano, Viola and Hirst
1.3 The Idea of the Numinous

Chapter 2

Contemporary Art and the Idea of the Numinous

2. 1 Fear, Awe and Dread: Francis Bacon and Damien Hirst
2. 2 The Uncanny: Antony Gormley
2. 3 Overpowering (*majestas*): Wolfgang Laib
2. 4 Energy or Urgency: Mark Rothko

Chapter 3

The Eastern Idea of the Numinous and Contemporary Art

3.1 Void or Nothingness: Robert Rauschenberg and Yves Klein
3.2 Time and Space: Anslem Kiefer

Chapter 4

Elements of the Numinous in Multimedia Art

4.1 Multimedia
4.2 Nam June Paik: Time and Emptiness
4.3 Bill Viola: Technology as Revelation
4.4 Atta Kim: Existence and Non-existence
4.5 Mariko Mori: Utopia as a Spiritual Experience
4.6 Jungu Yoon: Towards the Numinous Space

Understanding the Numinous

List of illustrations
Bibliography
Images

Introduction

Throughout history and across geographical, cultural and faith boundaries, from the Renaissance to Mark Rothko; from Islamic calligraphy to the aesthetics of *shui-mo hua* painting (水墨畫, Japanese *suibokuga*, Korean *sumukhwa*), artists have persistently striven to represent spiritual beliefs and values as well as to critique them. This book stems from an interest in the broad question of whether religious ideas remain a viable concern for contemporary art during a period in which secular ideas are dominant. ¶ In considering the relationship between contemporary art and spirituality, I have deliberately selected and interrogated the idea of 'the numinous', as derived from the Latin *numen*. My intention in positively embracing the term is to clearly differentiate my interpretation of spirituality from more restricted definitions, which remain tied to traditional religious usage of the concept. In particular, this book examines how, in the late twentieth and early twenty-first centuries, artists represent the idea of the numinous, and I apply this term and explore its meaning within the context of contemporary artistic practices which are distinguished by their engagement with multimedia, in contrast to traditional artistic techniques and methods of representation such as sculpture, painting or printmaking. ¶ Outside of the academic terrain, which encompasses religious studies and social anthropology, the term numinous is not a particularly familiar one. 'Numinous' and 'holiness' are words that are closely related; both conveying deeply felt spiritual significance. Con-

sequently, the words are sometimes seen as interchangeable. However, in interrogating the spiritual elements in contemporary art, I suggest that the use of the word numinous is a more appropriate choice than the terms holy or sacred since it not only captures but also transcends the essence of spirituality within a religious context, and therefore has the potential to signify a wider understanding of spirituality in contemporary society. In this study, it is important that the meaning and application of these terms are clearly differentiated from each other. Hence, in Chapter 1, I provide first a brief historical survey of religion and spirituality in art, and then examine how the term numinous has been conceptualized and utilised both historically, and in contemporary culture. This brief initial survey might imply that spirituality in Western art is generally associated with a value peculiar to the sphere of religion and mostly limited to a Christian context. On the surface it appears that the relationship between artists and religion in the twentieth century has been at best characterized by negativity and conflict and, at worst, by total disengagement and rejection. For instance, artists such as Chris Ofili, Andres Serrano, Bill Viola and Damien Hirst have produced much controversial work, which has sparked hostility between sections of the art world and some religious groups. However, their message does not necessarily carry an anti-religious attitude or purpose. Having said that, the argument in the second half of Chapter 1 complicates this, since I argue that these artists reformulate our beliefs about, and awareness of metaphysical existence in terms that are not defined by religious creeds or ethical criteria. Consequently, I suggest that such controversial artists cannot be regarded as anti-religious and that the numinous experience is accessed not only in a church or temple but also in the art gallery, which functions as a

kind of equivalent religious experience. ¶ From a theoretical perspective, I look first at the different interpretations of the numinous offered by Rudolf Otto, Carl Jung and Mircea Eliade. In particular, I draw upon Otto's discussion of the value of the numinous in his book *The Idea of the Holy*, written during the 1920s, and translated into English in 1958. This critical evaluation is subsequently applied to the artistic case studies throughout Chapters 2 to 4. ¶ Chapter 2 examines how the numinous is conceptualized within a contemporary context, and in particular how, from the middle of the twentieth to the early twenty-first century, artists have represented the idea of the numinous. This chapter is centered on a series of inter-related case studies featuring a number of artists, namely: Francis Bacon, Damien Hirst, Antony Gormley, Wolfgang Laib, and Mark Rothko. These artists, whilst retaining an interest in spiritual matters, have divorced the spiritual from the religious realm and attempted to redefine the notion in secular terms. ¶ In order to gain a clearer understanding of this somewhat unfamiliar concept, in Chapter 3, I consider some Eastern Taoist theories, definitions and discussions of the numinous. This chapter explores how contemporary art works might be interpreted as a vehicle for the numinous experience, and focuses on a selection of artists such as Robert Rauschenberg, John Cage, Yves Klein and Anselm Kiefer who have actualised the numinous idea, and through whose works I have identified some elements that are typical of traditional East Asian concepts of the numinous. However, this discussion remains too wide-ranging and therefore, to examine the numinous in detail, Chapter 4 focuses especially on the unique role multimedia plays in the artistic pursuit of the numinous and how this differs from traditional approaches to representation. ¶ Historically in the

arts, the 'medium' in the usual sense is the agent by which images are transmitted, yet the twenty-years period from the early 1990s has seen the rapid transformation of these processes. The rapid development of technology has resulted in the clear demarcation of 'multimedia' from other media. Chapter 4 comprises a series of inter-related case studies featuring relevant artists, namely: Nam June Paik, Bill Viola, Atta Kim, Mariko Mori and my own work. The works of these artists are commonly produced or presented using multimedia and have introduced the idea of the numinous into contemporary art through the integration of media technologies. My intention in this chapter is to examine the inherent potential of multimedia to facilitate specifically numinous experiences and how these differ from what has gone before. ¶ I make no apology for including my own work, although it is not usual practice for an author to do so. My creative practice concentrates on traditional Eastern spiritual thinking and the idea of the numinous. As an artist born in South Korea, but now living and studying in London, I have developed a particular viewpoint, which is an amalgamation of two contrasting cultures. Part of the reason for including my own work is that I include empirical evidence of the reactions of spectators to it, which both supports and modifies some of my arguments in this book. My intention has been to revise and develop the subject of the numinous from a contemporary viewpoint, emphasizing the concept of the numinous and its practical manifestation in contemporary art, and especially in multimedia practice. These works will be of interest not just to people with an inclination towards art and spirituality but also to those working with numinous themes and experimenting with multimedia technology, and who wish to widen their explorations.

Chapter 1

Chapter 1
Religion and Spirituality: A Brief Historical Survey

This chapter has two purposes. First, it aims to provide a broad but succinct overview of how spirituality has been characterized within the history of art, beginning with mystical, non-theistic conceptions through to present-day monotheistic expressions of divinity. It discusses how, in Europe since the Reformation, overtly religious art has been in steep decline, and how from the onset of modern industrial society, artists appear to be in conflict with specific religious ideologies and doctrines, sometimes even opposing the whole concept of religion per se. Reference is made to key artworks by established artists. I explore whether contemporary art and orthodox religion are indeed on a collision course, pursuing antagonistic and antipathetic values. Using four examples of artworks that have received considerable media attention and provoked hostile reactions from sections of some faith communities, I ask whether these incidents are an indication that contemporary art is suffering from spiritual bankruptcy. ¶ The second purpose of this chapter is to clarify the idea of the numinous, considering the different interpretations of the numinous offered by Rudolf

Otto, Carl Jung and Mircea Eliade. A critical evaluation is given of these definitions, and I offer my own understanding of the term as it will be utilised in the remainder of this book. However, whilst complex and multi-faceted, it will become evident that the definition of the numinous on its own is not sufficient to articulate the kinds of spirituality evidenced in contemporary art practice. Therefore, the terms 'spirituality' and 'sublime', both frequently distinguished from religion, are used in order to clarify more precisely what is to be understood by the contemporary idea of the numinous. ¶ 'Spirituality' in its usual sense is contrasted with the physical world and oneself, and may include an emotional experience of awe and reverence. Similarly, like the numinous, spirituality includes all aspects of mysticism, occult and religiously inspired feelings. Spirituality may also include the development of the individual's inner life through practices such as meditation and prayer, including the search for God, the supernatural and a divine influence. However, this definition of the spiritual is too general and nebulous and the term numinous better articulates the kind of spirituality evidenced in contemporary art practice. ¶ The 'sublime' and the 'numinous' also have a close connection. The sublime cannot be explicated and like the numinous, it is mysterious. Furthermore, Otto (1923) argues that we can detect the special characteristics of the sublime in art in the sense that great art has incomparable qualities and is beyond all possibility of calculation, measurement or imitation. For example, he invokes a Kantian definition when he asserts that 'In the arts the most effective means of representing the numinous is the sublime. This is the term given to what is absolute in traditional aesthetics theory' (Crowther, 1989). ¶ Otto tends to use 'sublime' and 'numinous' interchangeably, even stating that 'The sublime is nothing

but a suppressed and diminished form of the numinous, a crude form of it which great art purifies and ennobles' (1959 p. 68). Whilst agreeing with Otto that the sublime might stimulate the capacity to perceive the numinous, the term 'sublime' is more generally used when referring to nature specifically and its greatness or vastness. Hence, within the context of a dialogue about spirituality in contemporary art, I use the term numinous because it lacks such connotations.

1.1 Artistic Expression at Different Stages of Religious Evolution

According to the American sociologist Bellah (1976 pp. 28-50) humankind has evolved through five stages of religious development. He identifies these as first, the 'Primitive' stage of development, such as that practised by aboriginal peoples. This is followed by the second 'Archaic' stage, which includes the Egyptian and Native American religions. Stage three comprises 'Historical' forms such as ancient Judaism, Buddhism, Islam, and early monotheistic Roman Catholicism. Protestantism is cited as an example of the fourth stage, 'Early Modern Religion.' The final stage he labels 'Modern Religion' or 'religious individualism.' Bellah's characterisation of religious development is somewhat reductive and simplistic, limited by his colonial (and potentially racist) perspective, and hierarchical in its progressive philosophy. However, if we can reconceptualise Bellah's theory as five different but equivalent manifestations of spirituality – neither 'civilized' nor 'uncivilized', nor morally superior or inferior – his categories may provide a useful framework for considering how art has functioned as a vehicle for varied expressions of spirituality at different times and in different places. In the initial stage, for example, Bellah asserts that the idea of the sacred is manifested via a fascination with the perceived power of natural objects such as stones and trees. As such, the ordinary becomes transformed into something with great spiritual significance. For instance, in Korea, *Sung Hwang Dang* – stacks formed of stones (fig. 1), laid one at a time by large numbers of passing people over many hundreds of years – represent a place of worship for those who believed in the Ancient Korean gods. Located at the entrance of each village or town they claimed to protect believers from evil,

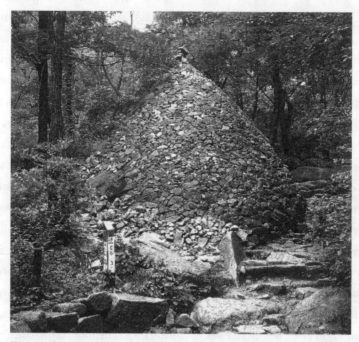

Figure 1. *Sung Hwang Dang* – stacks formed of stones, date unknown.

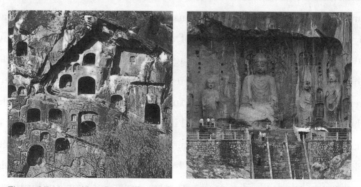

Figure 2/3. *Lung-Men Caves* (Fig 2), Construction began late in the Northern Wei dynasty (386–535) and continued sporadically through the sixth century and the Tang dynasty. Work at Long-Men culminated in 672–675 with the construction of a monumental shrine known as *Fengxian-Si* (Fig 3), which includes a seated Buddha more than 35 ft (10.7 m) high.

indicating the supernatural significance of the stones. These sorts of sacred objects frequently incur dread while simultaneously signifying a potent charm or spell. ¶ The sanctification of natural objects redolent of the 'Archaic' and 'Historical' stage of development has arguably changed to the adoration of certain artifacts. For example, Siren (1925) notes how the concept of the numinous is realized within early Chinese art such as the *Lung-Men Caves* of the Tang Dynasty (fig. 2), through the figure of the Buddha (fig. 3). He suggests that:

> Anyone who approaches this figure will realize that it has a religious signifi-
> cance without knowing anything about it. The religious element of such a
> figure is imminent; it is 'a presence' or an atmosphere rather than a formulated
> idea…. it cannot be described in words, because it lies beyond intellectual
> definition (Siren, 1925 p. 20).

Throughout the third stage, a dualism begins to emerge between the concept of a supernatural world and an earthly world. As old myths are put aside, monotheism fills the spiritual gap. In this stage, struggles begin between political rulers and the religious elite, such as the Emperor and the Pope in medieval Europe. ¶ The early modern stage of religious art, as defined by Bellah, begins when Europe went into a period of profound religious change during the Reformation of the sixteenth century. The Protestant Reformation stood in opposition to the beliefs of *tangible* holiness in the Catholic Church and rejected most of its teachings regarding devotional practice, language and imagery. The German reformer, Luther (1483–1546) was dismissive of aesthetic expression and visual practices, and it is interesting to note that, following the Reformation few new commissions were given for works of ecclesiastical art (Christensen, 1967 p. 140). The final stage of religious development, characterized as 'modern', has been

demarcated by a gradual shift in the balance of power from religious to secular authority in much of Western Europe, and particularly so during the nineteenth century. A corresponding trend is evident in religious art, which demonstrated a further decline from the onset of modern industrial society. Artists' concerns became secularized as an era of science and rationality dawned and the realm of religion lost its previous credibility and cultural dominance. This tendency was summarized by the nineteenth-century German philosopher, Nietzsche's infamous statement that 'God is dead' (Williams, 2001 p. 3). Since art is the visual history of the world, it is not surprising that secularism transformed it.

1.2 The Artist as Anti-Christ? Ofili, Serrano, Viola and Hirst

Whether or not we concur with either Bellah's reductive stages theory of religious development or with Nietzsche's proclamation, it is clear that religion and concepts of the spiritual have informed artistic practices to greater or lesser degrees at different historical and political junctures. In recent times, with or without the deity, the results of this relationship have often provoked strong reactions, extensive media coverage and cries of 'heresy' from certain quarters. At the close of the twentieth century a number of contemporary artists engaging with religious subject matter have sparked controversy amongst certain branches of Christianity in particular. In the following section I describe and evaluate four examples, which have caused considerable offence and have been interpreted by Christian faith groups as

an outright attack on fundamental Christian principles. ¶ The first instance occurred in 1999, when the Brooklyn Museum of Art came under fire for exhibiting a Chris Ofili painting entitled *The Holy Virgin Mary* (fig. 4, see p.146), which featured sexually explicit cutouts covered with elephant dung. Williamson (2004) records that:

> The Catholic Church, as well as New York City Mayor Rudolph Giuliani, expressed outrage. Giuliani denounced the exhibit as morally offensive and threatened to cut off funding to the museum and terminate its lease if it did not cancel the exhibit that included Ofili's painting (p. 112).

In a similar incident, Williamson reports how the National Gallery of Victoria, in Melbourne, Australia, was forced to close down its 1997 exhibition after two members of Christian groups in Melbourne attacked *Piss Christ* (fig. 5, see p.147), a photograph by US artist Andres Serrano, which depicts a small plastic crucifix submerged in a glass of the artist's urine. In both images the use of Christian iconography stirred up vehemently negative reactions amongst some religious viewers. This tension between art and religion also received a very public airing in relation to two other contemporary works by the artists Bill Viola and Damien Hirst. ¶ Viola's video, *The Messenger* (fig. 6), projected onto the west wall of Durham Cathedral, showed a naked man emerging from a pool of water. Thirty minutes before the press launch, protective screens were hastily installed to protect the supposedly delicate sensibilities of visitors to the sacred space. While attitudes towards nudity are not the same in all cultures, its acceptability depends on the cultural and/or religious traditions, which dictate what is proper and what is improper. The furore created by *The Messenger* arguably stems from the fact that nudity is often associated with sexual decadence or sexual arousal; therefore many Christians have

been led to believe that their clothing keeps them from sin, despite the fact that nudity per se is not condemned in the Bible. In fact the opposite is true. In Genesis, Chapter 3, God queries Adam, demanding to know: 'Who told you that you were naked?' This rebuke implies that, even from a Christian perspective, nakedness itself is not immoral and not, therefore, disapproved by God. Pope John Paul II reinforced this position in his text *Love and Responsibility*, writing:

> Nakedness itself is not immodest . . . Immodesty is present only when nakedness plays a negative role with regard to the value of the person, when its aim is to arouse concupiscence, as a result of which the person is put in the position of an object for enjoyment (1981 p.190-1)

Interviewed by Amanda Hogg on the outcry caused by the work, Bill Hall, who wrote the catalogue preface for the installation at Durham Cathedral, voiced other reasons for the actions taken by the religious authorities:

> This is a sensitive subject. I regret that screens were necessary however . . . the Dean and Chapter have a pastoral responsibility, not least for vulnerable people who might wander into the Cathedral and be affected by the work. An example given was that of the possible damaging experience of a child who perhaps had suffered sexual abuse. In the event, I regret that many of those who were offended by the nakedness of the figure were Christians. At the time I pointed out that on the other side of the door onto which *The Messenger* was projected there was an image of another naked man and that was Christ on the cross. Now for some reason, presumably to protect our sensibilities, we've draped a piece of cloth over that figure. As a result I believe we've lost something of the impact of crucifixion. We have lost the impact of the vulnerability of the figure on the cross and the utter degradation of crucifixion as a means of execution. It's the same vulnerability that is present in the birth of Christ, in the incarnation. It is the vulnerability of a baby (Hogg, 1997).

The final controversy considered here was in response to Damien

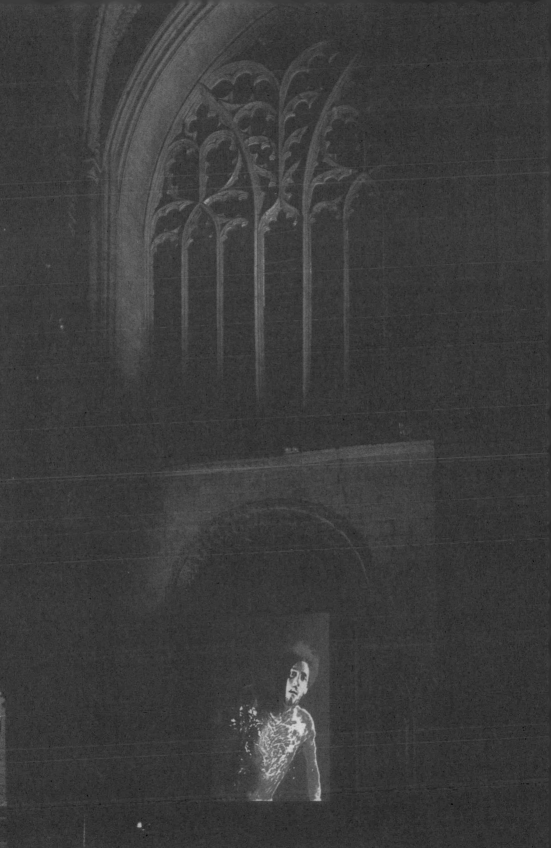

Figure 6. Bill Viola, 1996, *The Messenger*, Durham Cathedral.

Hirst's exhibition, *Romance in the Age of Uncertainty* at White Cube Gallery in 2003 (fig. 7, see p.148). On this occasion, Hirst presented a calf divided symmetrically, with each half preserved in a glass tank of formaldehyde; a series of cabinets that represent the deaths of the 12 disciples and the ascension of Jesus, and two butterfly paintings. Large cabinets containing various pieces of scientific glassware, skulls, crosses, and a generous splattering of blood, lined both sides of the main gallery, each under the gaze of their very own severed cow's head. The work represents the death of Christ and of each of the twelve Apostles. But in contrast with the gory scene of the latter, the Ascension is represented by an immaculate pure white cabinet, above which stands glassware, crowned by a stuffed dove in the midst of light. ¶ Various religious groups, including the Catholic Church and some animal rights protesters objected to the display. Martin Rowe, for instance, a spokesman for the animal rights protest group claimed: 'We feel there is no creativity or beauty or imagination in exploiting animals' (David, 1999). ¶ The Ukrainian Orthodox Church claimed that the exhibition *Romance in the Age of Uncertainty* was inconsistent with religious respect and reverence, issuing a statement which demanded that the organizers should remove the blasphemous exposition named *Jesus* and *Twelve Apostles*, stating that: 'It is a horrific exposition where the holy apostles are presented as twelve cows and bulls heads placed in twelve aquariums with formalin' (*Interfax*, 2007). By contrast, Richard Dorment, the art critic for the Daily Telegraph, excused Hirst on psychological grounds, arguing that: 'What Hirst is doing, I think, is not in any conventional sense religious. Rather, he is giving concrete form to the stories he heard as a child. In doing this, he is telling us about the origins of his dark imagination' (Dorment, 2003). ¶

Like the two artworks by Serrano and Ofili, both pieces by Viola and Hirst have created enormous controversy and caused huge offence to a variety of Christians because of their non-traditional approaches to deeply religious themes, what some might see as sacrilege. Are these artworks an anarchic act, deliberately intended to arouse anger and hostility and to alienate Christian audiences? ¶ Williamson argues that the significance of works such as those by Ofili and Serrano and the reactions they induce cannot be understood simply as a sign that anti-religious attitudes are pervading contemporary art. Instead, she pleads for a different approach to twenty-first century artworks dealing with concepts of religion and spirituality. They cannot be encountered and evaluated, she suggests, within the same frames of reference that have served traditional religious art, not least because 'They were not created to fulfill a Christian function: they were designed as independent artworks, to be displayed in the modern setting of the art gallery and museum, rather than in a church' (Williamson, 2004 p. 111). On this basis, in spite of some viewers' conviction that these two artists had set out to be deliberately offensive by their juxtaposition of sacred images with bodily waste products, other conclusions are possible. For example, elephant dung has formed part of many of Ofili's works before *The Holy Virgin Mary*, and is for the most part, according to the artist himself, a cultural reference to his own African heritage. Even from within a Christian viewpoint, Williamson argues that the works are not intended to convey an irreligious or offensive message:

The *Piss Christ* might remind a modern viewer what the image of the crucified Christ really meant. The use of urine here can therefore force the viewer to rethink what it meant for Christ to be really and fully human and attempts to show Christ crucified in new ways (Williamson, 2004 p.117).

In this context, the relevance of *Piss Christ* and *The Holy Virgin Mary*, lies in the willingness of their creators to address issues of the sacred and religious in an increasingly secular age. Similarly, I would argue that Viola and Hirst are engaged in subjectively reformulating our beliefs and awareness of metaphysical existence rather than making a dogmatic statement against Christianity specifically, or religion in general. Therefore, it would be a mistake to concur with those who jump to the conclusion that such artists are using their creative work as a platform to voice either anti-religious or anti-Christian attitudes. As Hall has argued with regard to *The Messenger*, nudity and sexuality do not go hand-in-hand. The work is neither obscene nor erotic, it would seem that the metaphor of nakedness in Viola's work should not be considered to be an expression of religious hatred, but as a symbol of vulnerability. ¶ Arguably, Viola, like his peers, appropriates the discipline of a particular religious tradition in order to explore a less restrictive concept of spirituality. None of the afore-mentioned artworks constitute religious art according to traditional definitions. In consequence, we can no longer approach this type of work from within the conventional demands and discipline of a particular religious tradition. However, where Serrano, Ofili, Viola and Hirst have engaged specifically with Christian iconography and beliefs, my intention from here on is to consider a certain trend within contemporary art that embraces the return of the spiritual in art in a manner which completely transcends traditional theistic religions and denominational demarcations. In order to distinguish such spirituality from orthodox religion, I use the term 'numinous', because the artists featured here are exploiting the idea of the numinous in their attempts to celebrate or revive a sense of the spiritual (or the numinous), which arguably has

been denigrated or ignored in recent times. ¶ In spite of the fact that overtly religious art has been in decline in Europe in the modern period, artists continue to explore concepts of spirituality in varying and unexpected forms to the present day. Although both medium and message have taken on different apparel over the ages, the relationship between art and spirituality is as vibrant as ever; representations of the numinous have changed but not disappeared. However, in order to apprehend contemporary spirituality in art, we must search in unconventional places and seek the numinous in the guise of secular ideas and forms.

1.3 The Idea of the Numinous

The origins of the concept of the numinous are contested. For example, the Concise Oxford Dictionary attributes numen to Latin roots in which the noun is variously translated as nod, command, will, consent, inspiration, divine will, divine power, divinity, deity, godhead, divine majesty, god, goddess. By contrast, Robert Schilling argued that *numen* is based on the Greek *neuma*, which 'signifies the manifestation, will or power of a divinity' (Eliade, 1987 p. 21). Schilling notes Festus's (1913) definition:

> The *numen* is, as it were, the nod or power of a god and suggests that some scholars have tried to give a completely different orientation to the term by identifying *numen* with a Melanesian word, *mana*. Schilling says that R. H. Coddington in 1891 defined mana as an autonomous, impersonal force, likening *numen* and *mana* to 'an impersonal active power (Eliade, 1987 p.178).

The German scholar Rudolf Otto proposed a contemporary notion of the idea of the numinous derived from the Latin *numen*. In *The Idea of the Holy: An Inquiry into the Non-rational Factor in the Idea of the Divine and its Relation to the Rational*, Otto defines the term numinous as the non-rational mystery behind religion, which is both awesome and fascinating. He asserts that the numinous is an experience containing elements of 'awefulness', 'overpoweringness' and 'energy' or 'urgency'. In Otto's definition, the numinous is clearly linked to a concept of the divine and the spiritual and the revelation or suggestion that a god is present. For Otto then, the numinous experience or numinous feeling characteristically inspires awe and reverence and is a state of mind or feeling, which must be evoked or brought into consciousness. In particular, Otto associates awe with:

> 'Energy' or 'Urgency' – 'Urgency' or 'Energy' is a force, which is most easily perceived in the 'wrath of God.' And it everywhere clothes itself in symbolical expressions –vitality, passion, emotional temper, will, force, movement, excitement, activity, and impetus. These features are typical and recur again and again from the daemonic level up to the idea of the 'living' God (Otto, 1959 p. 23-4).

Otto's definition of the numinous depends upon an experience or experiences, which originate from outside the self but are perceived within. ¶ While the Swiss psychiatrist C.G. Jung systematically builds on Otto's idea of the 'numinous'; his definition of numinous is no longer confined to religious discourses but rather transferred to psychoanalytic and psychodynamic contexts. For Jung, numinosity is an alteration of consciousness involving an experience of spiritual power, but one which passes through the personal unconscious.[1] He defines the numinous as a quality that is 'unconditional, dangerous, taboo, magical' (Jung, 1968 para. 59). ¶ Jung argues that the experience

1. Jung himself had a life-changing personal experience of the confrontation between the traditional ideas of the sacred and the profane. See his account in his autobiography, *Memories, Dreams, Reflections*, Chapter 2.

of the numinous is the experience of a collective archetype, which he describes as having 'natural numinosity.' (para. 82). Such experiences of the numinous may be healing or destructive, depending on the strength and attitude of the conscious ego along with the particular character of a given numinous power (Casement and Tacey, 2006).

A traumatized person, for instance, may distort the numinous, turning what could be positive spiritual experiences into paranoia. ¶ A third definition of the numinous is discussed by the Rumanian scholar Mircea Eliade. Eliade's definition of the numinous overlaps with Otto's. Eliade cites Otto's experiences of the 'numinous' to introduce his own particular refinements of the term 'sacred'.[2] Eliade classifies Otto's experiences of the numinous as:

> The feeling of terror before the sacred, before the awe-inspiring mystery (*mysterium tremendum*); the majesty (*majestas*) that emanates an overwhelming superiority of power; religious fear before the fascinating mystery (*mysterium fascinans*) (Eliade, 1959 p. 9).

Eliade builds on Otto's concept of 'wholly other' [3] by noting that numinosity exhibits diverse intensities, qualities and effects. Eliade is just as interested in difference as he is in similarity. And he does an admirable job of outlining these differences by examining a staggering amount of data across a wide variety of established religious traditions. A brief comparison of these definitions will help to clarify the way in which the concept is being deployed here. For our purposes, Otto's definition of the numinous is too vague and unsystematic. For instance, he understands the numinous as something linked with the divine, and the implication that a God is present is open to various interpretations. On the one hand, it might be argued that Otto reveals a definite Christian bias, because of his suggestion that especially Christian mystics

2. It means nothing more than is implied by its etymological content – namely, that something sacred is shown to us, manifests itself (Eliade, 1959 p.v10). 3. For Otto, the 'wholly other' means that which is quite beyond the sphere of the usual, the intelligible, and the familiar, which therefore falls quite outside the limits of the 'canny', and is contrasted with it, filling the mind with blank wonder and astonishment (Otto, 1959 p.v26). 'Canny' means 'sharp' or 'shrewd' and today we use it to mean 'perceptive and wise'. 'Uncanny' had meant specifically 'not safe to trust because of connections to the supernatural,' and eventually the word took on its modern meaning of 'supernatural,' 'weird' and 'strange.' So 'uncanny' came to mean something quite different than simply 'not smart.'

can experience the numinous feeling in its absolute and pure sense. On the other hand, he sometimes intimates that the numinous is a phenomenon that is manifested identically in all mainstream religions. Eliade's modalities of the numinous are arguably more coherent than Otto's. Eliade cites examples of the numinous from many religions belonging to different periods and cultures, arguing that the numinous is identical among all religions (1959 p. 15). ¶ Jung's definition is more detailed and systematic than Otto's. He examines how the idea of the numinous has gained credence in the post-modern world, demonstrating how the numinous is no longer confined to religious discourse but has increasingly become embraced by humanist, secular and scientific views of the world. Although Jung's idea of numinosity specifically focuses on the scientific exploration of the psyche[4], especially in the context of psychotherapy, some aspects of his definition can still be used when discussing how the numinous is represented in contemporary art practice. ¶ My own understanding of the numinous draws on elements of all three definitions. Like Jung, I conceive the numinous to be an experience of an archetype. In contrast to Otto, however, I argue that this experience is not limited to the context of organized religious traditions. One example of this can be seen in the East Asian idea of the numinous in Taoist philosophy, which is not dependent on the existence of a deity. However, it is unhelpful to conceive of Taoism and the numinous as interchangeable concepts, since Taoism makes no distinction between its understanding of the numinous and its understanding of *natural mysticism*. Therefore this interpretation is too all-encompassing and requires refining. *Natural mysticism* can be said to include the concept of the numinous, but at the same time it is more extensive and inclusive than the concept of

4. The interested reader can follow up the various index references to the subject in *Jung's Collected Works*. See also the forthcoming book by L. Schlamm, *Jung, Numinous Experience and the Study of Mysticism* (Routledge).

the numinous itself. One scholar of religion who clearly distinguishes the numinous from the mystical is Ninian Smart. He states that: 'the numinous in encouraging worship encourages a loving dependence on the other. The mystical in encouraging meditation encourages a sense of self-emptying' (1995 p. 71). Smart's classification is useful in that it overcomes the gaps left by Otto's blurring of boundaries in his discussion of the numinous and the mystical. ¶ In the remainder of this book, I incorporate Smart's distinction and understanding of the numinous because it implies an exclusive human dependence upon 'the other'. Although mysticism includes this concept, it also suggests partial reliance on human powers. Consequently, mysticism is a broader spiritual concept than the numinous because mysticism extends to include every kind of *inner* reality in addition to the *external presence* or reality of the numinous. ¶ Exposition of spiritual truth in language inevitably tends to stress the rational attribute of the archetype. Therefore, a true understanding of the numinous has to appear through the intrinsic characteristics of an object, which delivers numinous feeling. In that sense, I suggest that specific examples of contemporary art, including my own practice, function as effective vehicles to evoke or access the numinous. ¶ In conclusion, the concept of spirituality within modern art cannot adequately be expressed by relying solely on traditional theological jargon. Terms such as 'sacredness', 'holiness' or 'religious' carry considerable baggage, and are therefore apt to lead to misconceptions regarding the artists' intentions and their relationship to, and expression and understanding of, their own spirituality in the context of their creative work. ¶ One illustration of this concerns the term 'holiness'. Within and between the spheres of philosophy and religion, holiness has been conceptual-

ized and represented in different ways throughout history and is therefore problematical. Otto himself defines holiness as pre-eminently a living force in the religion and as a state of being that is set apart. It is divine but remains distinct from God's essence or the essence of religion. This definition has gradually come to dominate Semitic religious understandings of holiness. The problem for this book in adopting such a term lies in the additional ethical connotation of 'completely good' or 'moral goodness'. As Otto states, 'we generally take holy as meaning completely good. It is the absolute moral attribute, denoting the consummation of moral goodness' (1959 p. 5). Otto argues that the moral significance implied by the word 'holy' is an inaccurate understanding of the term and wishes to retain the spiritual qualities of holiness without the incumbent moralistic connotations. Therefore the concept of moral goodness implied by the term 'holy' is outdated and inappropriate, the numinous is greater than specific moral laws.

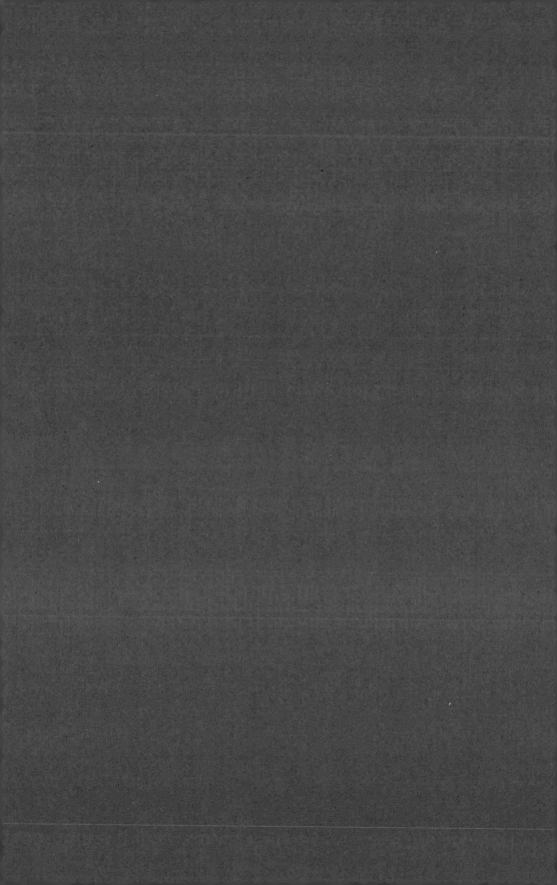

Chapter 2

Chapter 2
Contemporary Art and the Idea of the Numinous

The aim of this chapter is to explore, in the late twentieth and early twenty-first centuries, some outstanding artistic expressions of the numinous and to show how contemporary art has appropriated the idea. ¶ In the *Weather Project* (fig. 8) commissioned for the Tate Modern Turbine Hall, Olafur Eliasson explored his views on the relationship between the natural world and the urban world and between nature and human beings. Upon walking into the massive hall, visitors saw a giant glowing disc suspended from the ceiling. The light of this sun shone through a hazy mist, generated by humidifiers placed along the length of the hall. Visitors spent hours in the Turbine Hall, sprawled on the floor, gazing at the mirrors on the ceiling in an attempt to locate their reflections. Some were listening to music, reading books or sleeping. Some even grouped together to create interesting shapes with their bodies that were reflected above. Others had picnics on the gallery floor or sat in silent meditation. This scenery of the contemporary museum is far different from that of the nineteenth and early twentieth-century museums. Before the

postmodern era museums were only concerned with collecting work which had already established itself in a traditional ensconced within a modernist reading. As such, the museum functioned as a conservation laboratory, research library or programme; therefore museums were not entirely 'public-friendly' institutions. The museum was only a place where proved works of excellence would be exhibited and interpreted for the public. However, this kind of museum was not of real interest to the modern public and gradually museums evolved into places where the unknown and the experimental were given a chance to develop in all manner of ways. Since the 1960s, when museums encountered the problem of accommodating new contemporary forms, including happenings, conceptual art and electronic environments, their role has changed dramatically. Museums started to play an active role in reaching out beyond the traditional art audience. We now often find examples of museums that hold neither collections nor research. For instance, in 1969 the Anacostia Neighborhood Mu-

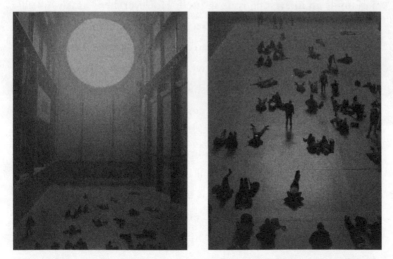

Figure 8. Olafur Eliasson, 2003, *Weather Project*, Turbine Hall, Tate Modern, London.

seum in Washington D.C. ran an exhibition programme called *Rats*. The purpose of the project was to examine the rat as an urban and especially as a slum problem, and to come to some understanding of the nature of the beast itself. In his essay, *Museum, a Temple or the Forum*,[5] Duncan states that in the *Rats* exhibition; 'museum techniques were used, museum professionals were involved, but most important all, there was a remarkable degree of participation by members of the Anacostia community' (2004 p.63). He argues that the Anacostia Neighborhood Museum is a centre that became a great museum serving an important and very necessary function in interpreting the immediate environment and the cultural heritage of a community, by means of exhibition techniques but without permanent collections. It might be added that museums collect ideas, words, sounds, stories and songs and arrange and rearrange them. Furthermore, the contemporary museum can also be a community centre hosting ballet classes, amateur arts programmes and the occasional bingo game benefit event for local charities. ¶ This change in the role of the museum is an interesting issue in itself. However, here I focus specifically on the role of the museum as a facilitator of religious or spiritual life. In his article Duncan frames an important debate when he argues that from a sociological perspective 'the contemporary museums to be places for reverence and worship of the object or places where the public gathers to debate, to consider issues of the day and the consequences of human actions' (2004 p. 67). Following Duncan, I propose that the contemporary museum is much closer in function to the traditional European church before the modern era. A church or cathedral in European culture is intended to be the centre of community, where congregations are encouraged to talk to each other,

5. This article is based on the 1971 University of Colorado Museum lecture, prepared for *The Journal of World History special number, 'Museums, Society, Knowledge'* (1972), reprinted with the permission of Unesco.

or at least to make contact and connect with each other. The European churches of the medieval era were not only places of religious relevance, but were also places where communities were formed by the public; where cultural opportunities were offered, and, at times, where trade occurred. Consequently the church was regarded as a multi-functional institution; more like a contemporary cultural centre. The mantle adopted by the museum in the modern world and its relationship with the public to some extent parallels the role played by churches in an earlier European epoch in which Christian culture flourished. However, as Duncan argues, it is not only the *functions* of the church which are mirrored by the museum today but also the fact that the museum provides an opportunity for reaffirmation of a spiritual life itself. As such, the museum or gallery has replaced the church as a site where the 'numinous' might be encountered. In this chapter, I argue that in the history of twentieth-century art, religious or otherwise, concepts of the numinous have moved into the museum and gallery setting where certain manifestations of contemporary art also evidence a spiritual dimension and create an equivalent religious experience. ¶ There have been many twentieth-century artists, such as Marc Chagall, Henri Matisse, Eric Gill, Jacob Epstein and Alfred Manessier, who have drawn upon their particular religious belief systems for creative inspiration. However, as mentioned previously, the numinous experience is not only reflected and expressed in specifically religious works of art but is also to be found disguised in secular ideas and forms by individuals who engage with and interpret spirituality from a broader, more personal and non-denominational viewpoint. For example, artists such as Mark Rothko, Francis Bacon, Barnett Newman, Yves Klein, Anselm Kiefer, Bill Viola, Nam June Paik, and

Damien Hirst have all, at certain times, produced works which allude to spirituality without recourse to any specified faith community or religious doctrine. For these artists, the concept of the spiritual presence clearly extends beyond the limited notion of *holiness* with its implications of moral goodness outlined in the previous chapter. Each of the following sections deals with how the idea of the numinous is conceptualized and represented in the work of individual artists. I examine how certain contemporary works exploit their artistic presentation in order to create an encounter between the viewer and the numinous.

Within the context of art history this inquiry will take as its starting point, the faith-seeking vision undertaken by the German Romantics, as well as a Nietzscheian philosophy that sought a reappraisal of society, proclaiming the death of God.

> The fate of our times is characterized by rationalization and intellectualization, and, above all, by the 'disenchantment of the world.' Precisely the ultimate and most sublime values have retreated from public life either into the transcendental realm of mystic life or into the brotherliness of direct and personal human relations (Weber, 1964 p. 154).

The twentieth century was ushered in to the tumult of overturned beliefs in Western society, heavy with what Max Weber describes as the 'disenchantment of the world'. The combating forces of capitalism and Marxism, the triumph of industry, the rapid development of the urban landscape, the spread of psycho-analytical theories and the rise of utopian tendencies, all pushed modern society further and further towards reconsidering its religious stance and the nature of individual existence, and ultimately to reconsidering the spiritual. This crisis unleashed a host of new forms within the metaphysical questioning of art, beginning with Dada and Surrealism.[6] From Wassily Kandin-

6. E.g. Max Ernst's *The Virgin Spanking the Christ Child before Three Witnesses* (1926).

sky to Francis Bacon, from Barnett Newman to Bill Viola, art continually forms diverse and opposing responses to this interrogation; sometimes with answers, sometimes with further questions. sometimes with intimations of the numinous.

2. 1 Fear, Awe and Dread: Francis Bacon and Damien Hirst

Fear is considered the deepest and most fundamental dimension in all strong and sincerely felt religious emotion, and the numinous feeling is also linked to the natural emotion of fear.[7] Throughout art history, there have been artists who have utilized the element of fear; for example, Francisco Goya, Caspar David Friedrich, August Strindberg, Edvard Munch, Henry De Groux, Lucio Fontana, Gino De Dominicis, Carl Gustav and Carus. However, in this chapter fear is taken to be a specific kind of emotional response of awe, which is wholly distinct from that of 'being afraid'. In the context of the numinous, this awe is more than fear proper; it is a feeling of peculiar dread not to be mistaken for any ordinary experience of dread. ¶ Two contemporary artists who have examined the themes of awe, fear and dread in relation to a concept of the numinous are Francis Bacon and Damien Hirst. In Francis Bacon's *Painting* (fig. 9, see p.149) the violence is brutal and blatant and the horror feels claustrophobic. It has wild and demonic forms and sinks to an almost grisly horror. However, an eerie beauty simultaneously hangs in the stillness. The terror or horror it evokes is not of the ordinary kind; it may be developed into something beautiful, pure and glorious. This multifaceted feeling is also found in various religious systems and spirituality with the form of 'daemonic

7. The fear is advocated in many religions. E.g. Ancient Aztec religion was a complex interaction between fear of nature, and a fear of the end of the world. Many Jews and Christians believe the fear of God to be devotion itself, rather than a sense of being frightened of God. It can also mean fear of God's judgment.

dread' (Otto, 1958 p.14); it includes a sense of the uncanny, the fright-ful, eerie, weird or supernatural and of being overpowered, which Otto calls *mysterium tremendum* and *majestus*. Otto explains that this feeling is experienced as a powerful sentient force, worthy of the ut-most respect. The *mysterium tremendum* inspires not only awe but also fear. This element of the numinous as defined by Otto can be applied to Bacon's depiction of horror or dreadful images, which signify the mortality of the human condition presented as *memento mori,* and the self-conscious awkwardness of life at its most exposed. ¶ In Bacon's painting popes scream from their cages, faces are twisted into a mess of bruised hues. Bacon aimed, as the poet Paul Valéry might have put it, 'to give the sensation without the boredom of conveyance,' to present, as he said, the stark 'brutality of fact' (quoted in Sylvester and Bacon, 1975 p.55). These conflicting feelings in Bacon's images direct-ly target the spectator's normal mental processes and nervous system and spontaneously invoke something numinous. To understand these psychological changes, Jung's concept of numinosity provides a useful framework. Jung adapts Otto's definition of numinosity in order to examine unusual, non-ordinary or heightened modes of psychological awareness, and explains the numinous as an evocation or an experi-ence of an archetype. Jung's 'archetype' is referred to by other names, both positively and negatively, by such competing terms as ghost, spir-it, god, devil and God.[8] ¶ For Jung (1953), the precipitating object of numinosity may be externally or inwardly perceived stimuli. Numi-nosity is either a quality belonging to a visible object or the influence of an invisible presence that causes a peculiar alteration of conscious-ness. Thus one of the hallmarks of the archetype's influence on the ego is numinosity. ¶ Damien Hirst's *A Thousand Years* (fig. 10), and

8. Vera M. Buhrmann suggests that the occidental fear of the numinous has led to its general rejection, with acceptance only in highly circumscribed social contexts such as Jungian analysis. See: *Journal of Analytical Psychology Vol. 29/1,* 1984, pp. 79-80, in PsycLIT Database APA, 1985.

Figure 10. Damien Hirst, 1990, *A Thousand years*, Charles Saatchi, London.
Figure 11. Damien Hirst, 2006, *The Tranquility of Solitude (For George Dyer)*, Gagosian gallery, London.

four triptychs: paintings, medicine cabinets and formaldehyde work entitled *The Tranquility of Solitude (For George Dyer)* (fig. 11), influenced by Francis Bacon, is a powerful and compelling series which brings to mind the fatalistic and darkly humorous view of existence. Hirst's *A Thousand Years* contains an actual life cycle. Maggots hatch inside a white minimal box, turn into flies, then feed on a bloody, severed cow's head on the floor of a claustrophobic glass vitrine. Above, hatched flies buzz around in the closed space. Many meet a violent end in an insect-o-cutor; others survive to continue the cycle. ¶ In this work, Hirst openly acknowledges his debt to Bacon and his absorption of the painter's visceral images and the fundamental feeling of horror or awfulness. Hirst adapted Bacon's dialectical relation between life and death and translates Bacon into 3-D; furthermore, he has updated and wittily extended the ridiculousness of the human condition to push the boundaries of art, science, the media and popular culture. Campbell-Johnston, a journalist from *The Times*, compares these two artists:

> The spectator can still feel the visceral horror that Hirst himself described when he had first completed it. But you can forget his medicine cabinets and fly-plastered canvases and bin them along with his spot and spin paintings – merely commercial spin-offs of his success. And perhaps it is this that speaks most clearly of the differences between the two artists. Where Bacon's life, work and philosophy seemed almost one, Hirst appears to capitulate to the tawdry demands of commerce and celebrity (Campbell-Johnston, 2006).

Campbell-Johnston criticizes Hirst's grandeur of vision as flawed, whereas I argue that the work of both Bacon and Hirst visualizes a numinous power that is virtually unmatched by any possible description of it. The nature of the numinous could only be suggested by means of the special way in which it is reflected in mind and feeling. Bacon and Hirst's works are both metaphor and symbolic expression

which actualize the state of numinous feeling through the creature consciousness of horror or fear. ¶ These works discussed here bring an argument that contemporary artists endeavored in various ways to combine their spiritual understanding with a mode of expression to create effective visual experiences that facilitate numinous feeling and experiences in their audiences by representing these numinous elements of fear and horror. ¶ All ostensible explanations of the origin of religion in terms of animism, shamanism, magic or folk-psychology are related to this special 'numinous' quality, often denoted as 'daemonic dread' or 'religious dread' and recognised as the first stage of religious development. Bellah asserted that the idea of the sacred is manifested through a fascination with the perceived power of natural objects such as stones and trees. This expression of fear is not fear of being harmed, but fear which is awesome and frightening. For example, the Old Testament is rich in parallel expressions of this feeling. Otto states:

> Especially noticeable is the Yahweh ('fear of God'), which Yahweh can pour forth, dispatching almost like a daemon, and which seizes upon a man with paralysing effect. Compare Exodus. Xxiii. 27: 'I will send my fear before thee, and will destroy all the people to whom thou shalt come...'; also Job ix. 34: 'Let not his fear terrify me'; let not thy dread make me afraid' (1959 p. 14).

Otto calls this kind of numinous feeling in the Old Testament 'awe' or 'awfulness'. However, Otto's understanding of dread is different from ordinary fear. Like Otto, Eliade uses the phrase 'terror before sacred' to donate a quite specific kind of emotional response, wholly distinct from our ordinary experience of dread.

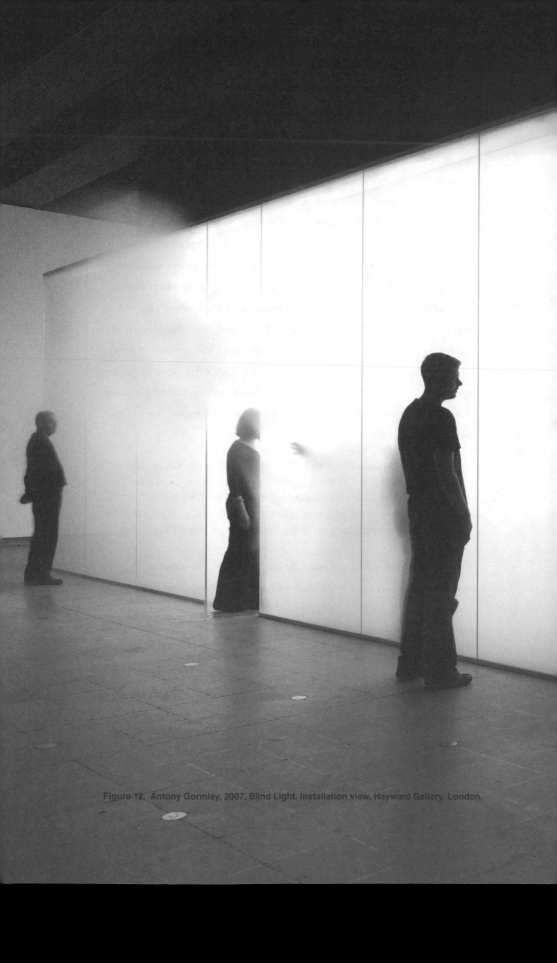

Figure 12. Antony Gormley, 2007, Blind Light, Installation view, Hayward Gallery, London.

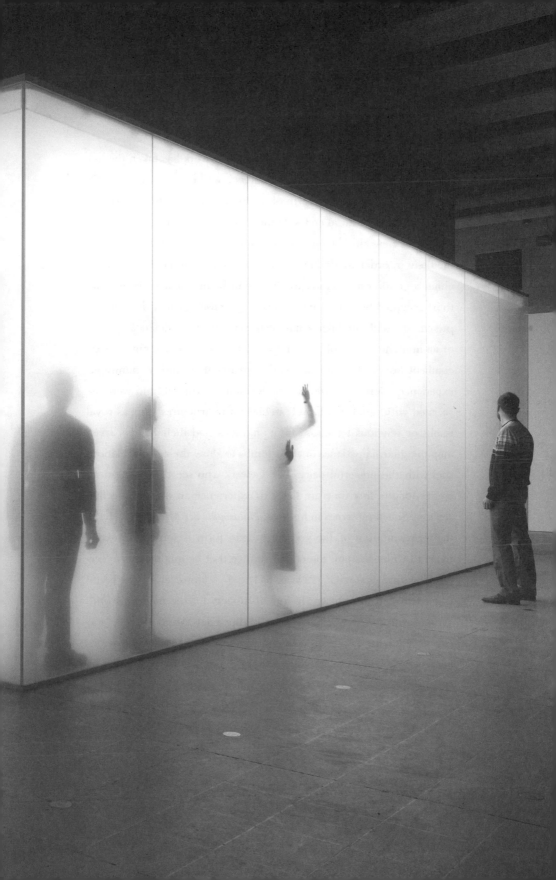

2. 2 The Uncanny: Antony Gormley

Over the last two decades, Antony Gormley's work has taken the human body (including his own) as a subject, and explores a space-filling and space-articulating form of sculpture which resists or extends traditional architectural codes. Some of Gormley's works specifically facilitate a new kind of numinous feeling in the viewer; they enclose the body in order to identify uncanny qualities, rather than creating either a condition common to all human beings or a space waiting to be occupied by a human presence. ¶ From ancient times to the present, the sculptural figure has been seen either as a defence against, or an uninvited guest of, unseen forces. For example a sphinx – a recumbent lion with a human head – creates that kind of numinous experience. Generally sphinxes performed the role of, and were associated with, guardianship of architectural structures such as royal tombs or religious temples. Many pharaohs had their heads carved atop the guardian statues of their tombs to show their close relationship with the powerful deity. The viewers who see these sculptural figures for the first time are likely to experience an uncanny feeling since, as Schelling writes in his book *Philosophie der Mythologie* (1842), the representation of the gods in human form is something extra-human or non-human, something strange that he qualified as a 'certain uncanny character' (1995 p. 654). ¶ However, it was Freud who excavated this ancient feeling of anxiety for the modern world. Writing during the terrifying years of the First World War, he was concerned to articulate this feeling of dislocated unease against stronger feelings of terror in Western literature and art. The definition he employed was that of Schelling – 'the uncanny' being 'something that

had been repressed but which suddenly returned' (Freud, 2003 p. 7). The shock of this return was especially associated with the double, or the sudden apparition of the ghost itself. Freud associated this form of the uncanny with the fear of castration, the death drive or desire to return to the womb, and found it in the terror of the evil eye, the fear of loss of sight and, above all, the double. ¶ Antony Gormley's *Blind Light* (fig. 12) at the Haywood Gallery held within it something of the uncanny which suggests important elements of the numinous. *Blind Light* was a cloud-filled glass room that was wet and disorientating. In this disturbing space, spectators became lost in light and vapour. Taking the body as its point of departure, the exhibition is an invitation to embark upon a journey. ¶ In 2007 I had an opportunity to experience the piece before the installation was open to the public. Entering the room filled with water vapour, I experienced a great fear of getting lost and a desire to leave the space immediately. The emotion I experienced when entering the installation was one of fear or dread, but it was a different kind of feeling from that encountered in ordinary life. It can be described as an ambiguous and complex feeling, creating both reluctance and curiosity simultaneously. However, when I entered the glass room with other members of the public, I did not experience the same emotions as I did when alone. This installation gave me a sudden shock of realization associated with elements of the uncanny and induced a sense of the numinous. C.S. Lewis's illustration of ghost stories makes clear this kind of uncanny feeling and its difference from ordinary fear:

> Suppose you were told that there was a tiger in the next room: you would know that you were in danger and would probably feel fear. But if you were told 'There is a ghost in the next room' and believed it, you would feel, indeed, what is often called fear, but of a different kind. It would not be based on the

knowledge of danger, for no one is primarily afraid of what a ghost may do to him, but of the mere fact that it is a ghost. It is 'uncanny' rather than danger-ous, and the special kind of fear it excites may be called Dread. With the Un-canny one has reached the fringes of the Numinous. Now suppose that you were told simply 'There is a mighty spirit in the room' and believed it. Your feel-ings would then be even less like the mere fear of danger: but the disturbance would be profound. You would feel wonder and a certain shrinking described as awe, and the object which excites it is the Numinous (Lewis, 1940 pp. 5-6).

It seems reasonable to conclude that something of the uncanny in Blind Light is similar to the numinous feeling C.S. Lewis describes here. Entering the vapour-filled room, visitors gradually lost all sense of open space, and were absorbed into the atmosphere of a palpable but opaque, translucent space. The conflict-ing feelings or sense of an uncanny experience in this installation are explained by Otto's concept of 'wholly other'. By 'wholly other', Otto means that which is beyond the sphere of the usual, the intelligible and the familiar, and therefore falls entirely outside the limits of the 'canny' and is in contrast to it, filling the mind with blank wonder and astonishment (1959 p. 26). Otto explains that the 'wholly other' has an aspect which co-exists with the power of fascination; a fascination which draws us to it with a force that is almost irresistible. At its most intense, this fascination becomes 'stupor' and transforms into the mystical 'shudder' or direct, complete contact with a state of the numen. The numinous dread and the fascinating combine in a strange harmony of contrasts, which Otto calls the 'whol-ly other'. Through this installation, Gormley presents the paradox of something clean, square, well designed, and safe, a dry architectural space as something without boundaries or secure shape, a shifting, watery place. The artist states:

Architecture is supposed to be the location of security and certainty about where you are. It is supposed to protect you from the weather, from darkness, from uncertainty. And Blind Light undermines all of that. You enter this interior space that is the equivalent of being on top of a mountain or at the bottom of the sea. In spite of all we have said about potential encounters, it is very

important for me that *Blind Light* is a room that has been dissociated from its room-ness so that inside it you find the outside (Gormley, 2007 p. 55).

In *Blind Light* the architectural space goes one step further to contest the very limits of spatial definition in such a way as to transcend the uncanny effects and to translate those effects into a numinous experience. Gormley's Blind Light is an environment that creates an uncanny kind of numinous experience. Contemporary art is then, recreating the powerful experience of the numinous through articulating the technological transformation of subjectivity in a postmodern world.

2. 3 Overpowering (*majestas*): Wolfgang Laib

The third element which must be added to any discussion of the numinous is that of 'might', 'absolute power' or 'overpowering'. This dimension is unapproachable, as may be seen in various religions and other manifestations of spirituality. Overpowering exists in relation to 'creature-consciousness', and is experienced as an object over and against the self. As Otto states: 'in contrast to "the overpoweringness" of which we are conscious as an object over against the self, there is the feeling of one's own submergence, of being but "dust and ashes" and nothingness' (1959 p. 20). He goes on to say that this creature feeling can only arise in the mind and accompanying emotions when the category of the numinous is called into play. ¶ The works of the German conceptual artist Wolfgang Laib superficially shape a formal language within Minimalist art and certain abstract painting. However, presenting his work as an offshoot of Minimalism does not do it

justice. It is more appropriately understood in the context of the idea of the numinous. Laib's works, which comprise natural substances, construct simple but potent monuments to bring the viewer into a state of nothingness via 'creature consciousness' or 'creature feeling'. Since the mid-1970s Laib has created objects and installations using naturally occurring elements such as milk, pollen, rice, beeswax, and marble. Laib's *Pollen* especially concentrates on the material itself. Ultimately, the weeks he spends in the fields and in the forest collecting pollen constitute the length of time required to engage in a silent dialogue with nature, from which the artist emerges imbued with a rare and profound knowledge gleaned from intimate contact with the elements. His approach demands extreme concentration or a form of contemplative reflection. It is a labour of several months' duration following the various blossoms from the hazelnut tree to the pine, from dandelions to buttercups. It constitutes a kind of spiritual exercise in nothingness redolent of Buddhism. He states:

> If we long to see a miracle, we need to look no further than our daily activities. Any task performed with concentration and respect is a marvel to behold... sitting, standing, lying down, and walking; these actions shared by everything that breathes proclaim our mutual interdependence one upon the other and all upon the universe (Taylor, 1999 p. 10).

Indeed, the repetitive character of this activity brings on a meditative attitude, a kind of self-forgetting where the artist becomes the instrument of a rite that envelops him, encompassing day after day the movement of the universe. He speaks of this repetitive and meditative process as a way of participating with natural materials rather than as a means of creating art. Laib considers this collection process itself to be anonymous, owing to his belief that its power and relevance

extends beyond the visible universe. Therefore, in Laib's work, art can be assumed to take on a spiritual function, constituting privileged access to the numinous. Here we can apprehend Laib's work in terms of 'creature consciousness'. He said that:

> If you only believe in the individual, in what you are, then life is a tragedy that ends in death. But if you feel part of a whole, that what you are doing is not just you, the individual, but something bigger, then all of these problems are not there anymore. Everything is totally different. There is no beginning and no end. (Farrow, 1996 pp. 22-3)

As with the countless instances of such beliefs, which occur from Tibetan *mandala* practice to Navajo sand painting, Laib works in silence and solitude but also stresses the importance of being part of a larger, collective whole. The awakening of creature consciousness in Laib's pollen-collecting process allows us to experience a feeling of nothingness against overpowering might; of dust and ashes against majesty. In this state of nothingness, we are introduced to a set of ideas quite different from those of creation or preservation. Rather, we perceive the presence of the *numen* through a process of almost religious worship or praise. Yet at the same time, Laib's pollen art has a physical impact that extends into an intermediate domain pertaining to neither its materiality nor its form. Instead it is located in what the philosopher Schelling called 'spiritual corporeality' (Norman, 2004 p. 33). Laib's notion of the autonomy of the pollen as a substance apart from form also derives from a deep relationship with the purity and simplicity he finds in pre-Renaissance art.

> Thirteenth-century Sienese painting, particularly that of Duccio di Buoninsegna surpasses Byzantine art in its illusionism and naturalism, and is also characterised by its delicacy and fluidity of form. Duccio's overall compositions

are to be thought of as visual dialogues between representation and void, figure and space, solid and fluid; between form the silhouettes of the figures in the 'foreground' and formlessness, the shimmering gold plane in what the modern viewer perceives as the 'background,' although it is visually far more active than that word implies (Bois and Krauss, 1997).[9]

Defined by the lines surrounding the figures, the gold in pre-Renaissance art produces its own numinous effect. The fact that it is as important as the foreground figures makes the painting a unified expression of form, colour, line, and pattern. Similarly, contemporary Minimalism replaces essence in art with presence and place: it relies on the void, the space around it and the space that since the Renaissance has been seen as distinct and separate from the art object. The Renaissance idea links with the twentieth-century genre of Minimal art including such artists as Mark Rothko, Yves Klein, Barnett Newman and Wolfgang Laib who express sympathy for the interdependence of form and formlessness found therein. The vast abstract fields in Minimalist paintings often present a monumentally abstract approach, a spiritual concept in which humanity stands in 'absolute power' in the space between the individual and the cosmos. In the face of this 'plentitude of power', we become transmuted into 'plenitude of being' which leads again to the mention of *numen*.

2. 4 Energy or Urgency: Mark Rothko

Rothko's painting, which frequently consists of floating rectangles of luminous color on enormous canvases, manages simultaneously to convey a deep sensuality and a profound spirituality that evokes a nu-

9. For a discussion of the rediscovery of the notion of formlessness in twentieth-century art, see Yve-Alain Bois and Rosalind E. Krauss, *Formless: a User's Guide*, New York: Zone Books, 1997.

minous feeling. In this section I examine Rothko's abstract painting which is especially linked to a notion of 'energy' or 'urgency'. The relation between the sublime and the numinous will also be examined. Rothko's painting *Black, White, Blue* (fig. 13, see p.149) is an impressive and mysterious work with its white, shimmering cloud-like rectangle which hovers in contrast to another of deeply radiant blue over a stark black background. With its brilliant white cloud-like rectangle and its gentle feathered edges of paint 'breathed', as Rothko once said, over the impenetrable black void of the background, this painting has the startling luminosity of a moment of apparition or revelation of an un-expected feeling. In this sense, the painting seems buoyant but at the same time meditative. Rothko uses a visual paradox and subtle colour variations to create a range of atmospheres and meditative moods to evoke a numinous feeling. Through the contrasting square layers ap-plied in *Black, White, Blue,* viewers begin to experience an adventure in an unknown space. Balanced subtly by another more sombre but radi-ant rectangle above it, the cloud-like mystery of the white rectangle is anchored within the space of the picture in a way that enhances its strange and almost spiritual radiance, thus establishing a formal and tonal dialogue at the heart of the work. This painting not only displays the full sophistication and subtlety of Rothko's brushwork, but also the extraordinarily emotive and elemental power which I venture to call the 'energy' or 'urgency' of the numinous. And, as Otto explains, this kind of 'energy' or 'urgency' is particularly perceptible in the symbolic expression of vitality, passion, emotional temper, will, force, move-ment, excitement, activity and impetus that are typical and recur from daemonic level up to the idea of the living God (1959 p. 23). Through this painting, which is buoyant and at the same time calm and medita-

tive, Rothko discloses a richly effected 'energy' and the presence of 'urgency' by using a simple technique: nothing more than subtle variations of colour, proportion and scale. During the 1940s Rothko had turned to themes of myth, prophecy, archaic ritual and the unconscious mind and his imagery became increasingly symbolic. However, by the 1950s, he had removed all reference to either the natural world or myth from his painting and his work darkened dramatically. By abandoning all reference to objects and every element of materiality, Rothko found a way to create an art of deep numinous intensity by asserting colour as its own entity. Rothko established colour as a real physical presence which inspired an overpowering sense of awe that could distract, divert or get in the way of the viewer's meditative experience of his paintings. Art historian and Rothko biographer, Dore Ashton wrote in her journal on 7 July 1964:

> What is wonderful about Mark is that he aspires, and is still capable of believing that his work can have some purpose – spiritual if you like – that is not sullied by the world, Rothko was an artist who clearly yearned for the sublime (Ashton, 1964).

As Ashton suggests, Rothko's painting could be seen as having descended from an eighteenth-century conception of the Romantic Sublime, epitomised by that boundlessness of nature that evokes religious awe. The sublime is the quality of greatness or vast magnitude, whether physical, moral, intellectual, metaphysical, aesthetic, spiritual or artistic. In aesthetics, the term especially refers to a greatness with which nothing else can be compared and which is beyond all possibility of calculation, measurement or imitation. Furthermore, this element of the numinous may continue to be embedded in the general aesthetics of the 'sublime' as expressed throughout nineteenth-century West-

ern art such as the paintings of J.M.W Turner and Frederic Church. In twentieth-century art, various characteristics of the sublime are also represented in the work of Matta, Wifredo Lam, Jackson Pollock, Barnett Newman, André Masson, Lee Mullican, Wolfgang Paalen, Robert Smithson, Shirin Neshat and Tobias Collier. I focus specifically on a Western interpretation of the sublime and consider how this relates to the numinous, since, as Otto argues; 'in the arts nearly everywhere the most effective means of representing the numinous is the sublime' (1959 p. 65). Like Otto, I argue here that the 'magical' or 'the sublime' is nothing but a suppressed and diminished form of the numinous; a crude manifestation which art purifies and ennobles. Although many critics have concluded that Rothko's paintings possess, and attempt to communicate, an innate sense of the sublime, which everyone at sometime experiences, I argue that Rothko's painting facilitates inherent numinous elements of 'energy' or 'urgency', a sacred place where two or more contrasting elements (earth, air, water) meet and resonate in the eye and consciousness of the viewer. Such numinous elements comprising the uncanny, a sense of the overpowering, energy and urgency can be compared to the notion of the void and nothingness discussed in East Asian philosophy. In the next chapter I address this issue in more depth. The case studies there will analyze the numinous elements represented in some postmodern Western art, showing that it can express the concept and feeling of the numinous through incorporating the Oriental idea of way of numinous.

Chapter 3

Chapter 3

The Eastern Idea of the Numinous and Contemporary Art

The concept of the numinous can be more adequately articulated by referring to a traditional form of East Asian spirituality. The Sung connoisseur Tung Yu writes:

> Furthermore looking at the things made by heaven and earth One may find that one spirit causes all transformations. This moving power influences in a mysterious way All objects and gives them their fitness. No one knows what it is, yet it is something natural . . . (Rowley, 1959 p.5)

In his discussion of Chinese landscape painting, Tung Yu argued that the purpose of traditional Eastern *Shanshui* painting was not to reproduce exactly the grandeur of mountain scenery but rather to grasp an emotion or atmosphere so as to capture a sense of the numinous. For instance, beautiful mountain scenery was an expression of the numinous to his contemporaries in the way in which the artistic process distanced themselves from the actual world they were living in. It was a symbolic Utopia to both those who saw it as well as to those who only heard about it. ¶ Whereas, traditionally, Western artists' approach to spirituality is usually limited to the expression of a formal belief sys-

tem, Eastern painters identified and explored the non-rational mystery behind religion and the religious experience. The concepts of 'void' or 'nothingness', and 'moving focus' or 'multi-viewpoint' devices in the traditional form of *Shanshui* painting relate directly to the concept of the numinous. Early *Shanshui* painting suggests the unlimited space of nature as though one had stepped through that open door and had known the sudden breath-taking experience of space extending in every direction and infinitely into the sky. This device has expanded our apprehension of time and space, and also significantly expanded spiritual qualities, including numinous feelings. ¶ Chinese painters become so aware of the significance of the *non-existent* that the voids in an artwork were considered to convey more meaning than the solid areas. In East Asian culture, this interconnection between the concept of the void and spirituality dates from the thirteenth century. In *Shanshui* painting, for example, voids were meant to suggest the 'mystery of emptiness' based on the Taoist speculations about the significance of the non-existent – 'a void which was never mere atmosphere but a vehicle for spiritual realization' (Rowley, 1959 p. 71). The voids created within the image through fog and mist, are not, of *themselves* considered important, but play a significant role in facilitating the appearance of the mysterious. Such a conception of the 'void' in *Shanshui* painting has had no parallel in traditional Western landscape painting because this has always emphasized the existent rather than the non-existent. This is clear from the manner in which the sky was perceived as a space-filled realm and not a vehicle for importing a sense of the infinite. These kinds of ideas about what, in Western art, would be termed 'negative space', constitute a key theme in Eastern Asian art and symbolize imaginative representations and modes of access to the

numinous itself. ¶ This unique attitude toward space such as movement in time or multi-viewpoint in *Shanshui* painting is also one of the most memorable numinous characteristics in artistic expression. This principle was implied in the arrangement of the group by movement from motif to motif through intervals. For instance when we see *Shanshui* scroll painting, our attention is carried along laterally from right to left, being restricted at any one moment to a short passage, which can be conveniently perused. The right timing of these qualities depends on lateral movement rather than on movement in depth. Arguably, this kind of early principle of multi-point of view or moving focus used in *Shanshui* painting has expanded the Western apprehension of measurable single fixed perspective. For instance, this movement of the eye in *Shanshui* painting must be experienced in time, like literature, because we must see it step by step if we are to apprehend all of its subtleties. Viewing *Shanshui* painting is something the viewer actively engages with, zooming in on individual parts of time and space. As such, the experience it engenders might change our concept of what an image means and turn the viewer into an active agent, manipulating both time and location. Its properties of realistic depiction while simultaneously inducing a sense of un-naturalness and strangeness in the image differs considerably from ordinary viewpoints because there is no stationary viewpoint and no fixed horizon. ¶ In the postmodern world, Western artists began to explore an effective way of describing the Eastern mode of presenting the numinous to the Western viewers. In this section, I discuss the crucial question of what these numinous elements in contemporary art signify. I particularly focus on how Western contemporary art has been influenced by Eastern ideas and representations of the numinous, and how this differs from traditional Western approaches or representations of it.

3. 1 Void or Nothingness: Robert Rauschenberg and Yves Klein

Robert Rauschenberg provides an excellent illustration of this concept of 'void' or 'nothingness'. He was fascinated by the work of the Abstract Expressionist Willem de Kooning, and in 1953 asked the artist if he could erase one of his drawings as an act of art (fig. 14). Allegedly, it took Rauschenberg a whole month to achieve a sheet of paper relatively clear of marks. The result has become a cherished and resonant work from that period. It was a significant gesture because, as Rauschenberg states: 'I kept making drawings of my self and erasing them, and they just look like that erased Rauschenberg. It was nothing...It was a gesture or a protest against abstract expres-

Figure 14. Robert Rauschenberg, 1953, *Erased de Kooning*.

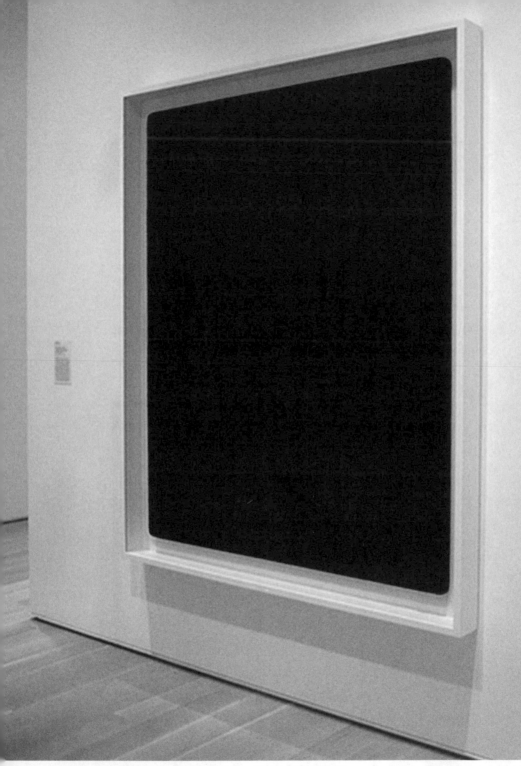

Figure 15. Yves Klein, 1960, *Blue Sponge Relief (RE 40)*.

sionism' (Rauschenberg, 1997). Thus, according to Rauschenberg, this erasing process was far from a spiritually inspired act. However, Rauschenberg's idea of erasure has parallels in the Eastern concept of the void, and becomes an effective way of describing to a Western audience the numinous quality of the void in Eastern philosophy. Within Chinese art, the concept of emptiness was influenced by a unique cultural conception of the void, based on Taoist speculations about the significance of the non-existent; a void which was never mere atmosphere but the vehicle for the numinous which may be thought of as spiritual emptiness or nothingness. It is an essential feature of the Oriental style to make the strongest impression with 'almost nothing'; to make emptiness more important than solidity. In this sense, the void functions as a negation in order that the numinous may become actualized. ¶ The association of Rauschenberg's idea with an Eastern notion of emptiness is also evidenced in John Cage's work and that of Fluxus artists who referred to Rauschenberg's idea of erasure or emptiness in order to deliver an Eastern notion of the void. For instance, Rauschenberg's *White Paintings* series in the 1950s are said to have directly influenced Cage in the composition of his completely 'silent' piece titled *4'33'* which epitomizes the Eastern idea of emptiness or nothingness. Consequently, *Erased de Kooning* serves as a good example of how the removal of one subject can allow for the appearance of another 'wonder'. As such, I suggest that these imageless (or soundless) expressions by Rauschenberg are an effective vehicle to deliver numinous feeling. ¶ A precursor of the postwar avant-garde, Yves Klein's body of work broke new ground and blended traditional artistic media, performance and spiritual exploration. Klein's monochromes (fig. 15, see also p.150) function as an expression of the

numinous, and the painting illustrated here exemplifies the emptiness and simplicity of East Asian Taoist thought. ¶ Klein inaugurated his defining series of monochromes in 1957 using his patented pigment known as International Klein Blue (or IKB) in a search for immaterial spirituality. His monochrome blues and pinks create meaning or emotion by alluding to, or evoking some spiritual quality beyond the materiality of their pigment.[10] In the application of blue, Klein wanted to avoid there being any visible sense of surface to his works. Pure pigment had an ethereal quality that fitted Klein's purpose perfectly. They should have no edge and should reveal no brushstrokes, for his monochromes were not to be conceived of as paintings nor as windows but as materializations of the void. Klein's monochromes were a retreat from the artifice of modern life and would provide a spiritual alternative. As Anish Kapoor has stated: 'Yves Klein was the first artist of the avant-garde to mythologise the material with which he worked. He made it clear through his life and work that artists don't just make objects, they make mythologies' (quoted in Anon., 1995). Kapoor rightly asserts that Klein hoped to provoke awareness in the viewer of the profound reality of the supernatural aspects of the void through the use of monochrome or simplicity of colour. This conception behind Klein's artistic creation was most effectively realised in ancient Chinese ink paintings. It is evidenced in the words of Li Shi-hua:

> When the ideas are carried out, the brush must possess the power of spiritual suggestion through emptiness (*hsu*); hsu meant that the 'brush comes to an end but the idea is without limit (*wu chiung*).' Furthermore, in employing the brush, it is necessary that every brush should hold within itself pictorial reality (*shih*) and yet at the same time emptiness (*hsu*), for by being empty, then the idea becomes spiritually alive (*ling*); by being spiritually alive, there is no trace of obstruction (*chih*); by being not obstructed, then there is wholeness of spirit . . . (Rowley, 1959 p. 77).

10. For an interesting discussion of the use of blue pigment, and the spiritual and commercial value traditionally attributed to it, see M. Baxendall (1972), Chapter 2.

I argue that the term *hsu* is used here in the cosmic sense to signify the creative entirety and potentiality of primeval origins inherent in the Western conception of the numinous. It can also be argued that the term reveals the distinctive character of an East Asian concept of spirituality to a Western audience. Chinese ink painting emphasized spiritual moods through simplicity and beyond form; hence, when they tried to convey the numinous, Eastern painters preferred subtle monochromes and emptiness. Klein believed man had a kind of sixth sense, an innate sensibility to this mystical zone (1969) that could stimulate numinous experience, and he attempted to bring the idea of the numinous and its method of representation into Western culture. His paintings suggest a state of flow and relativity between the seen and the unseen, symbolic of the operation of the numinous. Viewers are mystified and enraptured by forms that are so simplified and intangible that they suggest an Eastern concept of emptiness.

3.2 Time and Space: Anslem Kiefer

Anselm Kiefer's vision of transcendence is invariably laced with pathos and he has pointedly stated that, for his generation, 'There is always hope, but it must be combined with irony and, more important, skepticism' (2005 p. 27). Kiefer was born in Germany in 1945, only months before the end of the Second World War. Perhaps for this reason irony, skepticism and hope run through his more than thirty years of art making like major arteries. In the late 1960s, Kiefer began to ask fundamental questions regarding the nature of religion and its

relationship to intellectual and political life. He began by exploring his great interest in myth and history. His early interest in the paintings of Vincent van Gogh, the sculptures of Auguste Rodin, the poetry of Rainer Maria Rilke, and the later work of Marcel Duchamp and Andy Warhol, would evolve into a more critical reflection on the intellectual and spiritual values of the modern image. However, I focus here only on the artist's specific understanding of time and space, which has connections with the multi-viewpoint used in *Shanshui* painting.

The *Heavenly Palace* (fig. 16) installation is conceptually linked to Kiefer's 35-hectare studio compound at Barjac, at the foot of the *Cévennes*, where since 1993 he has been working on a vast *Gesamtkunstwerk*; a total work of art, a synthesis of installations. Kiefer has been transforming his 35 hectares of abandoned silk factory into a construction site where he creates a numinous place. But how does this space convey numinous feeling? The work done on the La Ribaute studio compound is unified by its complex of above-ground and below-ground pathways. Like *Shanshui* painting, this special movement must be experienced in time, because we must see it step by step if we are to apprehend all its subtleties. ¶ In this installation, Kiefer's approach to time and space often combines insightful modesty with dark irony in complex and paradoxical ways. This work proposes that our concept of heaven can only elevate us if it carries a critique of history along with its numinous aspects, rather than referring to a merely religious heaven. His use of fragmentary images reflects a belief that heaven cannot be summarised in a single image or place, but is better symbolized by a series of glimpses, each both convincing and unconvincing from different viewpoints. The sheds and glasshouses scattered across the wilderness at Barjac are ideal containers for paintings and sculp-

tures, providing multiple viewpoints that give rise to complex feelings which induce numinous experience. ¶ Viewers can both literally access and experience this panoramic space and traverse it in imagination. It seems ultimately to focus on the quest for the one single space in which, just a moment ago, the act of sacrifice is or was performed. At the same time, Kiefer presents the metaphysical act of visualization as an act of model building and of painting. The German poet Rainer Maria Rilke once spoke of the 'cosmic inner space' that 'extends through all beings'; a curious metaphor, since we usually think of space as surrounding things and not as extending through them; however, it is the latter concept that has been confirmed by modern physics. When asked about the underlying theme of his art, Kiefer uses a metaphor of the numinous: 'All painting, but also literature and all that goes with it, is always about walking around something that cannot be said, something you can never get to the centre of' (Kiefer and Auping, 2005). When Kiefer concentrated his energies on painting he did so as a means of expressing an artistic conception that explored remote spaces of history and myth. Kiefer used painting as a way to explain the vertical axis of time. In his paintings, he tells stories in order to show what lies behind history and to realize a fundamental experience of time. This phenomenon can be seen in early Egyptian and Archaic Greek paintings. Some earlier Western artists have also realized this principle and used it in a series of hanging paintings and album pieces, for example Michelangelo's *The Last Judgment* (1535-1541) in the Sistine chapel in Rome, and El Greco's *The Agony in the Garden* (1590s). As noted earlier, in East Asian culture, the use of multiple viewpoints is one of the main characteristics of traditional *Shanshui* painting. The principle of multiple points of

view or moving focus used in *Shanshui* painting suggests possibilities of numinous experience. Indeed, these paintings had to be experienced as a sequence of pictorial motifs, to be read by the spectator like so many pictographs. ¶ Rowley (1959) illustrates the basic difference between the Eastern use of moving focus and the Renaissance passion for perspective, arguing that 'The use of one-point perspective is even more damaging than in architectural inscenation because it violates our experience of nature' (1959 p.62). Rowley notes that the invention of scientific perspective, used in Western painting from the fifteenth century onwards, has also restricted spiritual space to a single vista. However, it is significant that Kiefer has combined these two differ-ent spiritual presentations of East and West in one single installation. The attitude toward space in *Heavenly Palace*, of movement in time, is one of the most memorable numinous characteristics of his artis-tic expression. The *Heavenly Palace* suggests not only a space through which one might wander but also a space which implies more space beyond the picture frame. In this way, a ruin in Kiefer's painting forms a whole '*Heavenly Palace*' that transcends ordinary feeling and enters the realm of the numinous. ¶ Otto specifically identified numinous

Figure 16. Anselm Kiefer's studio in Barjac

feelings as creature-feeling, mystery (mysterium), awe (tremendum) and fascination (fascinans). However, due to the internal complexity of Otto's definition, I have attempted to reiterate those terms in simpler ways and specifically to identify numinous elements as fear, awe, uncanny, overpowering (majestas), and also combining Energy or Urgency and some Eastern ideas of the numinous such as void, nothingness, time and space. ¶ The main aim of Chapters 2 and 3 has been to clarify and amplify the elements of the numinous within late twentieth-century art. The central issue has been how contemporary art explores and reveals the numinous. I have focused on providing a succinct definition of what the numinous means with reference to selected artists' work. However, for the purposes of this investigation into the relationship between contemporary art and spirituality we are still in an ill-defined, vast and unwieldy terrain; hence Chapter 4 narrows the field by focusing explicitly on how contemporary artists have turned to technological innovation to explore and express their developing ideas of the numinous through their creative practice.

Chapter 4

Chapter 4

Elements of the Numinous in Multimedia Art[11]

In this section, I raise the question of whether media technology is effective in developing a sense of the numinous. The last couple of decades have seen a dramatic transfer of human capabilities to machines, especially those involving vision, thought and memory. In the age of technological advance, multimedia has probably had the most powerful and drastic effect on forms of representation. In this chapter, I look at how multimedia technology as tools of communication and visualization has affected our belief systems and inner lives, especially our vision, thought and memory; specifically, how certain works by Nam June Paik, Bill Viola, Atta Kim, and Mariko Mori exploit multimedia technology in order to create an encounter between the viewer and the numinous. These artists have created numinous elements using multi-media technologies, to produce effective virtual experiences that facilitate numinous feelings in their audiences by re-presenting traditional subjects in a spiritually significant manner. In my survey of these artists, I look also at my own artistic practice, which I present here as a case study among the other artists. The case studies focus

11. This section mainly features part of my practice-based research project commenced between 2004-2008 at University of the Arts London. Since beginning my research in 2003, I have been supported by the joint research group FADE (The Fine Art Digital Environment) of Camberwell College of Arts and Chelsea College of Art and Design. My focus is on how technical characteristics are deliberately manipulated to emphasize a particular theme in the way that contemporary artists explore notions of the numinous.

particularly on the question of how the use of multimedia enabled these practitioners to reveal or express the numinous in unexpected ways. My argument centres on the proposition that multimedia, in contrast to traditional artistic techniques such as sculpture, painting or printmaking, exhibits unique characteristics which facilitate artistic explorations and revelations of the numinous. Specific attention is paid to the tripartite relationship between the artwork, the application of multimedia technologies and the idea of the numinous. There is a discussion and critical evaluation of the spiritual intentions of each artist's practice.

4.1 Multimedia

Within the context of contemporary art, multimedia – by contrast with traditional artistic techniques and methods of representation such as sculpture, painting or printmaking – exhibits unique characteristics that facilitate the exploration and revelation of the numinous, as defined and described in the previous chapters. In order to pursue this theme, it is necessary to clarify precisely how I am using both the term 'multimedia' and the 'numinous'. The purpose of this chapter is devoted to the former. This chapter considers various definitions of the term 'multimedia'; it distinguishes multimedia from new media and mixed media; and finally, it outlines the precise way in which I intend the concept to be understood in this book.

> New media art is an art genre that encompasses artworks created with new media technologies, including digital art, computer graphics, computer ani-

mation, virtual art, Internet art, interactive art technologies, computer robot-
ics, and art as biotechnology. The term differentiates itself by its resulting
cultural objects, which can be seen in opposition to those deriving from old
media arts (i.e. traditional painting, sculpture, etc.) (Tribe andJana, 2006 p. 4)

Although critics and theorists such as Tribe and Jana (2006) have in-
voked the term 'new media' to reference artistic practices,[12] that are
dependent on technological means of production as opposed to craft
skills, the phrase is unsatisfactory. Media is *always* 'new' in the sense
that it changes continuously and is constantly modified and redefined
by, for example, emerging technology, cultural context and, signifi-
cantly, through creative interaction with the public. Consequently, the
idea of 'new media' as a defined territory of artistic production is
problematic. Whatever is new today is old tomorrow and trying to
define the limits of these changes is futile. Change is the very essence
of new media. For this reason I have adopted the alternative term
'multimedia' here. However, this concept still requires definition. As
media theorist Crary has pointed out, in the modern world there is no
field that remains untouched by the pervasive effects of technological
developments. He notes that visual media transcend traditional disci-
plinary boundaries:

New technologies of image production have become broadly institutionalized
within the military, medicine, science, media, and the arts, with transforma-
tion of social practice and the instantiation of new belief structures (quoted in
Hansen, 2004 p. xiv).

The last couple of decades in particular, as Crary notes, have wit-
nessed a dramatic transfer of human capabilities to machines, espe-
cially those involving vision, thought and memory. As a result, media
technology has had a profound effect on modes of representation,

12. See also; Boyd (1999), Chun and Keenan (2006) and Hansen (2004).

not least in the field of fine art practice. ¶ The term multimedia can be traced back to the 1970s when it was adopted as a means of describing experimental practices involving a collage of film and slide projections. However, by the mid-1980s through to the late 1990s, the term gradually found more general usage and came to mean almost any software and hardware involving images and motion pictures (Mcgloughlin, 2001 p. 5). During the 1990s, this tendency to define anything computer generated as multimedia took on a new dimension as existing media began to be translated into binary information to be stored digitally on computers. As the name implies, multimedia denotes the integration of multiple forms of media including text, graphics, audio and video. ¶ It should also be noted that the term functions as both a noun and an adjective, referring to either the process of integration of a variety of different forms, or as a medium with multiple content forms. For example, a presentation involving audio and video clips would be considered to be a multimedia presentation. Educational software that involves animation, sound and text is called multimedia software. Similarly, CDs and DVDs are generally conceptualized as multimedia formats since they have the potential to store large amounts of data – a feature frequently demanded of multimedia forms of presentation (Garrand, 2001 p. 4). Most recently however, the prevalent meaning of multimedia is connected with a category of computer technologies. ¶ Although Manovich (2001) uses the term 'new media', his definition is arguably interchangeable with the term multimedia, being simply a conflation of the concept of multiple formats and digital technology. In his text *The Language of New Media*, he defines new media as 'Graphics, moving images, sounds, shapes, spaces and text that have become computable; that is, they comprise

simply another set of computer data' (Manovich, 2001 p. 2). Technically, Manovich's definition is accurate since almost every PC built today includes multimedia features such as a web-camera, a CD-ROM or DVD drive and a high-quality video and sound card. Moreover PC technology is designed to be compatible with most media appliances such as MP3 players, digital video recorders (DVRs), interactive television and advanced wireless devices. However, despite these facts, within the visual arts the concept of multimedia expands beyond the boundaries of computable data and signifies a more sophisticated and extensive phenomenon than simply computer generated art. Most (although not all) contemporary artists understand computers as a transmission medium or as a medium whereby digitization is used as a means to facilitate the distribution of a pre-existing medium, rather than referring simply to an integration of electronic tools.

This approach removes any possibility of fetishising computer technology. As such, multimedia work is dependent upon process rather than object for its meaning, involving the appropriation and convergence of many and varied processes to convey an idea. Consequently, the kind of multimedia practices cited in this chapter are not limited to computer-generated artworks but include the work of artists such as Bill Viola and Nam June Paik who, since the 1960s, have worked with analogue cameras and television formats but have also gone on in the 1990s to experiment with digital technologies. ¶ It is also important to distinguish between 'multimedia' and 'mixed media'. Within the visual arts, mixed media has tended to refer to art works and creative practices which combine various traditional mediums such as painting, sculpture, collage, chalk, ink, photography and so on. The concept of mixed media is therefore defined in terms of the

combination of one or more mediums, which in other contexts would be used as the single main form of representation. While multimedia art shares common territory with mixed-media work, in that both invite the transgression of traditional boundaries or limitations and depends upon combining hitherto distinct forms of expression and representation, multimedia is arguably a more complex entity. Where mixed-media work is confined to combinations of visual mediums, multimedia brings together whole different dimensions and sensual experiences. Text, image, still and moving photography, film, DVD, video and sound in the form of digital hardware or software, which are juxtaposed in ways that engender a wholly other type of artistic encounter. ¶ The term 'multimedia' as used here captures both the development of digital media, often referred to as 'new media', as well as more traditional and established forms such as film, photographic plates and gramophone records which are part of modern media technologies. In what follows, I begin chronologically with the Fluxus movement of the 1960s, which marks the emergence of the video era, and continue up to the current age of digital media.

4.2 Nam June Paik: Time and Emptiness

In this section I examine certain artworks, mostly from the 1960s and 1970s, by Nam June Paik, which use multimedia technologies. In the late1960s, the emergence of low-cost video recording seemed to promise not only corporate commercial interest in electronic media, but also opened up new possibilities of creative presentation. As a composer, performer, and video artist, Nam June Paik played a pivotal role in introducing artists and audiences to the possibilities of using video as a form of artistic expression. His early videotapes provide insight into a broader understanding of the artist's use of multimedia as a creative medium. However, my main aim here is to demonstrate how Paik exploits the possibilities of media technology to provide the viewer with a virtual experience of inner phenomena or spirituality.

I consider the two particular themes in Paik's work that illuminate this, in order to show how the artist expresses the numinous with reference to his culturally specific understanding of Eastern spirituality, namely time and emptiness. ¶ The first work to illustrate Paik's exploration of emptiness as a spiritual theme is *TV Buddha* (fig. 17, see p.151), an installation at Galeria Bonino in New York. The piece comprised an antique Buddha statue seated directly opposite a video monitor in which the Buddha statue gazes at his own image on a video screen, projected by a closed circuit video camera. The work creates an infinite loop. Paik's installation is a self-conscious reference to the practice of *zazen* meditation in traditional Zen Buddhism, a form of meditation where the practitioner is seated opposite a white wall and contemplates it while remaining motionless. The goal is to enter a spiritual realm beyond time and space, represented by abso-

lute emptiness. However, in Paik's version, the picture appearing on the video monitor consistently returns the meditator (and viewer) to their physicality, a condition that cannot be escaped. As such the Buddha, the symbol of Oriental wisdom, is forced to become a modern Narcissus (Decker-Phillips, 1998 p. 102). ¶ In this work, Paik creates a simple modern-day shrine in the gallery, but at the same time viewers are confronted with a discordant and conflicting experience in what appears to be a struggle for meaning between a spiritual encounter of a non-theistic variety (i.e. Buddhism) and its manifestation via the materialistic media that constitutes Western technology. It is clear that, through this installation Paik draws attention to a certain antithetical (or at least ambivalent) and uneasy relationship between transcendentalism on the one hand and new technology on the other; an ambivalence which was equally present in Paik's own character. However, I suggest here that, as the strengths of both transcendentalism and technology become apparent, they enhance one another. Importantly, I believe that Paik manages to manipulate and exploit this conflict in order to engender a numinous feeling. In other words, in deliberately highlighting the conflict between the self and the perception of the self, the artist engineers a catalytic situation, which ultimately sparks a positive interaction between Eastern spirituality and Western technology. ¶ In the installation *TV Buddha*, Paik's efforts utilise the unique qualities of the new medium of video technology to evoke great fascination amongst viewers and indicates his desire to provide a means through which an audience is able to explore an idea of the numinous. As noted earlier, Rudolf Otto states that the element of fascination (*fascinans*) is significant since it represents one of the clearest forms of the numinous, in which the religious experi-

Figure 18. Nam June Paik,1962/4, *Zen for Film*, approximately 23minutes of 16 mm film, Flux Hall, New York.

ence appears in its pure intrinsic nature and in heightened experience, without recourse to conventional practices of worship or belief in a deity. Hence, Paik's conscious and deliberate attempt to produce a fascinating experience for the audience might therefore be interpreted as a similarly conscious and deliberate attempt to reveal the numinous.

¶ Another work in which Paik explores the concept of emptiness as a vehicle for encountering the numinous in art is *Zen for Film* (fig. 18). Paik's film was presented at the Flux Hall, Canal Street in New York in conjunction with forty other short films created by several of the artists associated with Fluxus. This piece is typical of the kind of work described by Rush as part of 'a minimal aesthetic … inherited from concrete poetry' which sat alongside 'Dada manifestos and experimental music', all of which were 'becoming an important element in the development of media art' (Rush, 1999 p. 25). ¶ It comprised

unexposed film running through a projector. The resulting projected image consisted of a rectangle of bright light, occasionally altered by the appearance of scratches and dust particles on the surface of the damaged film material. By using the emptiness of the image as the object of the artwork, this is a film that depicts only itself and its own material qualities, and is intended to encourage viewers to oppose the flood of external images with their own interior images. Paik's effort to remove the complexity and high-speed characteristics of hi-tech culture, is informed not only by the artist's own Eastern philosophical background but also influenced by Fluxus. In this respect it is analogous to John Cage's exploration of silence as a non-sound in his music. Korean art critic Young Woo Lee states:

> Cage combined the openness and the 'Void' of Eastern Zen with the pragmatism of America. Just as John Cage's *4'33'* placed listeners in the unfamiliar role of opening their ears to random, ambient phenomena and listening to themselves, and to the environments in which they were immersed, so Nam June Paik's *Zen for film* also affected the spectator (Lee, 2000 p. 145).

As noted earlier, the spiritual quality of 'emptiness' is emphasized in Zen. During the Tang period (618–907 AD), Zen Buddhism in China developed from the interaction between *Mahāyāna* Buddhism and Taoism, since Zen was frequently perceived to be simply a foreign version of Taoism. Consequently, the inter-philosophical dialogue and exchange that took place between Taoism and Zen imported such Taoist elements as the doctrine of emptiness (Maspero, 1981 p. 83). During the 1960s John Cage and Fluxus artists appropriated these oriental elements of emptiness, silence, quietness and slowness. In contrast to noise and speed they attempted to negate the spectacular by exaggerating the simplicity of what was already evident. Paik in

particular reworks these ideas for a contemporary and Western audience using technological devices and adapting media technologies rather than calling upon the traditional craft skills of brush and ink to depict oriental concepts of spirituality. In this sense he opened up a new possibility of spiritual representation and experience.

In addition to the idea of emptiness, Paik also works with concepts of time and temporality in his attempts to reveal something of the numinous. Time and the limits of time has frequently been a fundamental subject of philosophy, religion, and art because of the manner in which it invariably raises questions concerning mortality and the permanence of the universe. The ambiguities of time have long been discussed by Western philosophers especially when it comes to considering the relationship between temporality and a deity or deities. For example, the Ancient Greeks posited their Olympian deities as a timeless absolute when they started to emancipate themselves from the human gods of Olympus (Holland, 1999). In contrast, Buddhism uses the image of a wheel of time, symbolizing the belief that time is a cyclical phenomenon which consists of repeating ages that happen to every being in the universe between birth and extinction (Castaneda, 1999). By contrast again, the Judaeo-Christian concept, based on the Bible, is that time is linear. Its beginning is located in the act of creation by God. The Christian view also assumes an end of time; expected to happen when Christ returns to earth in the Second Coming to judge the living and the dead. In Christian belief, God is the creator, the maker of all things; he therefore made time, and so cannot be in time. God is not present in any place, but every place is present to God. As such, the Christian concept of God is one that transcends temporality. ¶ Such religious and philosophical ideas

of time are suggestive of a close relationship between time and deities, or at least, a corresponding element in the spiritual realm. These ancient philosophies also define human beings as corporeal, confined by time and space; consequently only God can operate beyond time. Moreover, if time is infinite it cannot be quantified, since infinity is not a calculable concept. ¶ However, this understanding of time, which requires the existence of a deity, is not appropriate in a contemporary context. The scientific approach to the concept of time has overturned the ancient philosophical concept. Time is now defined by the process of measurement and by the units chosen to do this. Thus the definition of time became an operational one. This idea is based on the Newtonian idea of time. With Newton, the concept of time is considered to be 'absolute' and to flow 'equably' for all observers. This Newtonian idea of time as a calculable entity, associated with a scientific and rationalistic philosophical approach, allowed new ways of understanding the human condition. This association plays a key role in Paik's artistic exploration, and in particular in the way in which he utilizes time-controllable technologies to allow new possibilities of expressing the numinous. ¶ In the videotapes that Paik produced for sale, such as *Merce by Merce* (1978), Paik emphasizes the importance of the temporal dimension in his work, speaking about the 'dance of time' and referring to temporality as both 'reversible and irreversible' (Decker-Phillips, 1998 p. 231). The commencement of television services in 1936 which initially adopted a live format, inevitably served to emphasize the live and physically linear aspect of time. However, by the 1960s, the invention of videotape storage provided broadcasting companies with the ability to pre-record, edit and repeat programmes. This was soon followed by the domestic video recorder (VHS), which

finally allowed the viewer to record programmes and watch them at a time and place of their own choosing. Against this technological background, Paik argued that 'Once you are taken in videotape, you are not able to be dead' (Kim, 1992 p. 35). He intended to convey the notion that a video-taped image exists in the eternal present. By either rewinding or fast-forwarding the user is able to send an image forward or backwards in time. Video technology thus provides a sensation of the possibility of accessing the past, present and the future simultaneously. ¶ In his thesis 'Random Access Information', Paik wrote that 'When you make films, you dye the chemicals with nature, through the lens. But in television, there is no direct relationship between reality and the picture, just code systems. So we got into time' (Decker-Phillips, 1998 p. 47). Here he argues that the film camera has a direct representational function. The video camera, on the other hand, does not produce the light rays received but codes them into abstract data, which in turn must be decoded. Thus the material fixing of time also makes it manipulable. Hence, Paik was able to assert that historically video technology itself gave humans their first experience of being able to both turn back time and to go forward in time. Editing devices and video technique offer endless possibilities for the formal structuring of time in terms of visual presentations. It could be said therefore, that multimedia has provided the viewer with the circumstances to access the *out of ordinary* or that, which is beyond the natural order of things. ¶ Paik actualises this phenomenon in his first international satellite installation *Good Morning Mr.Orwell* (fig. 19, see p.151). The event comprised a live production linking WNET TV in New York and the Centre Pompidou in Paris via satellite, as well as hooking up with broadcasters in Germany and South Korea. George Plimp-

ton hosted the show, which combined live and taped segments with TV graphics designed by Paik. It was aired nationwide in the US on public television and reached an audience of over 25 million viewers worldwide. Through this work Paik demonstrated the possibilities of multi-media technology. In particular, he emphasized how the viewer could recognize events happening at the same time but in difference places by simultaneously uniting one-picture screen events from different temporal locations and contexts. Thus, real time editing technology made possible an experience no longer restricted to a specific time or space. By using multimedia technology, video artists therefore, no longer present their work in any one particular place but potentially, in *every* place. As with Paik's explorations of emptiness, these kinds of time-controllable experiences can provide us with a feeling or experience of the numinous because the numinous is an entity induced by that which is characterized as *out of the ordinary* or beyond the *natural order of things*, and so, outside time itself. ¶ Paik's distinctive use of multimedia technology is a vehicle through which to examine the experience of inner phenomenon. Each artwork discussed above is a primary example of his persistent attempt to delve deeper and deeper into the core of numinous expression. As such, Paik pushes even further his rejection of the various parameters associated with technology as medium, to the extent that his use of both video and film in creating 'art' transcends the ordinary purposes of video and film.

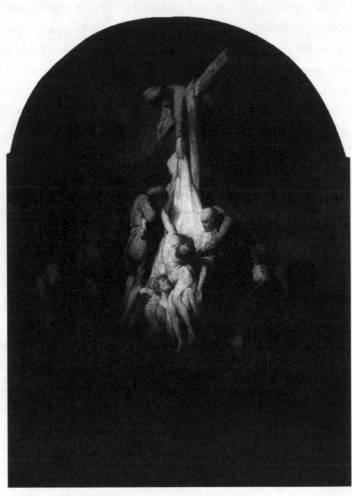

Figure 20. Rembrandt, 1634, *The Descent from the Cross*.

4.3 Bill Viola: Technology as Revelation

In this section I discuss Bill Viola's cinema-digital-video hybrid technique. Viola's work represents a model which demonstrates the legitimacy of positioning video in the context of analogue and digital media forms and the conceptual linkage among video, analogue processors, and digital computers. I propose that Viola's unique appropriation of multimedia technology offers the possibility of numinous expression through his use of light. ¶ There are a number of artists in Western art who have demonstrated a deep fascination with the theme of light as a symbol of spirituality For example, in the seventeenth century, the dramatic light in Rembrandt's paintings may be interpreted as a powerful expression of the numinous in art, and is illustrated in his work *Descent from the Cross* (fig. 20). The depiction of Jesus' body wrapped in linen is centralised in the picture, glowing luminously against a dark background. The way in which Rembrandt is able to isolate and emphasize a specific aspect of his subject matter with the use of this light effect is both dramatic and unique. By the skilful positioning and direction of light in his paintings, the artist articulated a sensation of the numinous by contrasting light and dark so as to symbolize the sin committed by man against the Son of God. A further example of the use of light in art to manifest the numinous as an aspect of religious experience can be seen in the extensive use of stained glass in medieval Gothic architecture. ¶ Contemporary artists have revisited the theme of light in relation to spirituality, using the possibilities offered through new technology in contrast with the traditional mediums of painting and sculpture. Significant examples include Dan Flavin's series Icons (1961-1963), Peter Sedgley's *Video*

Disques (1968) and Bruce Nauman who asserted that *The true artist helps the world by revealing mystic truths* (1967). Some of these works have become widely regarded as milestones within the history of the electronic medium. ¶ In a more recent context, Viola's works are distinctive in their use of new technologies to draw our interest and curiosity towards the spiritual world and expressions of the numinous, through his fascination with the different uses of light in artwork. For instance, in the installation *Five Angels for the Millennium* (fig. 21, see p.152), Viola projected video images and dramatic sound tracks in large dark spaces. In this piece the viewer enters a large darkened gallery and encounters five projected images running simultaneously. Each element is recognizable as water and the images are accompanied by sonar-like bleeping noises, the sound of rushing water and other aquatic sound effects. ¶ Viola has called *Five Angels* 'another form of the passions, an unframed versus a framed experience, and enveloping emotional experience like that of a church' (Viola, 2003 p. 48). In fact, Viola's description of an 'experience like that of a church' is more precisely the experience of the numinous itself. In Viola's installation, the numinous is represented through the use of new media technology, and in particular, the manner in which Viola manipulates this technology to explore the spiritual dimension of light in a new way. In this sense, Viola continues a path previously trodden by artists such as Rembrandt in that he continues to articulate the numinous through enhancing brightness, and contrasting this luminosity with darkness. Rudolf Otto argues that the juxtaposition of brightness and darkness is a motif that recurs throughout the ages as people look for means of expressing numinous experiences. He uses the example of religious architecture to illustrate his assertion, writing that:

The semi-darkness that glimmers in vaulted halls, or beneath the branches of a lofty forest glade, strangely quickened and stirred by the mysterious play of half-lights has always spoken eloquently to the soul, and the builders of temples, mosques, and churches have made full use of it (Otto, 1959 p. 68).

In Viola's French installation *Stations* (fig. 22), a computer-controlled five-channel video with sound is installed in a dark room in which suspended nude figures are projected onto vertical slabs of granite. Bodies appear to fall through the air or topple into the water, and are mirrored on polished slabs placed on the floor accompanied by a lulling soundtrack of underwater humming. The figures drift slowly out of their frames. The reflections in the slabs on the floor give an illusion of infinity; of that which has no beginning and no end. ¶ This multimedia installation grapples with various implications of different stages of life such as birth, growth and death. It is a connection is which indicates Viola's mystical inspiration derived from Sufism, and the importance to him of Jalaluddin Rumi's philosophy. Rumi proclaimed that 'with every moment a world is born and dies. And know that for you, with every moment comes death and renewal' (Viola, 1995 p. 42). On the other hand, the name of the work *Stations*, also brings to mind the Stations of the Cross. Similarly, the nudity of the human figures and their suspension in space is a clear evocation of images representing the crucifixion of Christ. However, it would be a gross misinterpretation of Viola's work to limit it to either a mystical Sufi or a conventional Christian one. There is evidence that Viola simply employs those universal understandings of spiritual images to create a feeling and explore a far wider concept of the numinous idea, one which is ultimately identical in all varieties of religion and spirituality. Throughout his career Bill Viola has drawn meaning and

inspiration from various kinds of spirituality and religious doctrines such as Christian mysticism, Zen Buddhism and Islamic Sufism. However, Viola subjectively reformulates those beliefs and our awareness of metaphysical existence rather than restricting his ideas to any specific religious tradition. Despite which, there persists a simultaneous religious or spiritual presence in his work which references the original sense of religion as being the *numen*. To create this numinous experience, Viola distills his understanding of the numinous through various representational means such as water, fire, light, and darkness and silence. In particular, he draws upon the specific facets of multimedia technology to maximize the various sensory experiences associated with these traditional symbols of spirituality. ¶ Historically, media

Figure 22. Bill Viola, 1994, *Stations*, American centre, Paris..

theorists have often argued for a clear differentiation between technologies that depend on 'analogue' as opposed to those with 'digital' characteristics. For example, in his defining use of the term 'new media' Manovich stresses the separation of analogue and digital media, stating that 'New media is a particular type of computer data, something stored in files and databases, retrieved and sorted, run through algorithms and written to the output device' (Hansen, 2004 p.32).

From this position, critics such as Manovich are able to assert that in the changeover from analogue to digitization in multimedia art, the role of video should be abandoned since it now symbolizes an exhausted medium that has been superseded by digital computer technology. In contrast, Yvonne Spielmann, professor of visual media at the Braunschweig University of Art, argued in her article in *Art Journal*, that:

> Video has not become obsolete with the development of computers, but on the contrary has incorporated analogue computer applications since the early 1970s and has further enriched an electronic media culture increasingly oriented toward signal processing and digital imaging (Spielmann, 2008 p. 55).

Spielmann argues that video shares significant features with the digital media because they share the potential to produce imagery in any direction and dimension in an open structure. Therefore, from an art historical perspective, it is not necessary to separate the terms 'analogue' and 'digital'. In art, when a medium comes into the world, it must come to grips with intelligible media culture, existing genres, institutions and other pre-established media. For instance, art histories commonly agree that photography and film will continue to play key roles in technological development. This tendency can be seen in Viola's work. ¶ By Manovich's definition, the work of Paik and that of more contemporary practitioners such as Viola inhabit entirely dif-

ferent spheres. However, from the perspective of this particular research, the bifurcation of analogue and digital becomes an arbitrary opposition since both artists are united by their desire to explore and represent concepts of the numinous using the technological means available to them at a particular historical juncture. It is for this reason that I use the term multimedia here, as opposed to 'new media' which relegates analogue artistic practices to some kind of unrelated and archaic 'old' medium. The distinction emphasized here is between technological methods of artistic production per se and traditional artistic mediums such as oil painting. Viola himself has acknowledged his origins:

> All the threads of the medium were present when I came into it in 1970: image manipulation, intervention into the actual hardware like in Nam Jun Paik's work, the spreading it out in space was in the work of Les Levine and that of Frank Gillette and Ira Snyder (Viola, 2003 p. 27).

In this statement, Viola clearly identifies the logical continuity of his work with the artistic curiosity and investigation of new technological mediums dating back to an earlier point in the twentieth century when, for example, the Sony Portapak became commercially available in 1966. As a result tape was cheap and direct. It could be shot for hours on end and offered instant playback. Artists who came from music, performance, film, and the fine arts with the intention of contributing to the formation of a new medium largely carried out their experiments using video techniques, and one consequence was that the use of light as a subject in art became more corporeal and widespread. Fluxus artists such as Bruce Nauman, Vito Acconci, and Nam June Paik also examined conceptual questions associated with the position of video technology in relation to other technological mediums in the

1960s and 1970s. By the digital video revolution of the 1980s and 1990s, widespread access to sophisticated editing and control technology was common, allowing many artists to work with video and to create interactive video-based installations. Currently the digital video camera, projector and personal computer are well-established key tools for many contemporary artists. Those artists who use digital devices are learning to enjoy the ability to record the passing of light, shadow, and sound as well as to cut, loop, slow down, collage and examine and transform fragments of experience. As such, the developments in digitalization are a physical concept where development is visually evident, whereas the tangible technology that has grown out of these concepts could be said to be the 'light behind the screen'. We can observe this phenomenon at play in Viola's work. In several installations the artist has experimented with this idea by digitally converting to video film shot at high speed (384 frames per second) and then projecting the resulting video back at normal speed. Mark Hansen has noted that 'Viola's work uses the cinema-digital-video hybrid technique to expose the viewer 'beyond what is visible' to natural perception and to encounter the spiritual in our midst' (Hansen, 2004 p. xxvi). Hansen argues that multimedia technology itself has had a powerful effect on the collision between spirituality and technology. Consequently, for artists such as Viola, the presentation of the numinous interrelates in many ways with surrounding media and involves dynamic and symbiotic processes which not only shape the emergence of a new medium but also give rise to original methods of revealing and evoking an experience of the numinous in the contemporary world. What distinguishes Viola's work from other artists is the manner in which he intentionally deploys multimedia to catalyze a tem-

poral and luminous experience to present a sense of awe and wonder which is outside ordinary experience. Viola demonstrates that media is not just a vehicle for a reproduction of real life but also can be a vehicle that delivers sensations indicative of a spiritual sphere beyond the real world.

4.4 Atta Kim: Existence and Non-existence

Atta Kim, born in 1956, is a South Korean photographer who has been active since the mid-1980s. He investigates complex philosophical issues such as human identity and questions of existence. Atta works in series, spending five or more years producing extensive bodies of related works. Through the *ON-AIR* project, he has created images which contain a great spiritual feeling emphasizing the idea of the numinous by contrasting visible objects between invisible histories of time. By capturing images of nature over a long time span, Atta compels viewers to look at them with renewed attentiveness, transforming the material reality of the objects into its numinous representation.

The Silk Road (fig. 23) was constructed by the artist's observing silk-worms eating mulberry leaves, and taking a single photograph of the activity using an 8-hour exposure. The resultant image transforms the work of the silkworms on the leaves into a natural abstract painting, which is drawn by light against a green backdrop. The combination of silkworms as moving objects, leaves being eaten by the silkworms, and the ever-changing weather conditions of light and wind, coalesce into a kind of contemporary action painting which explores meaning and

Figure 23. Atta Kim, 2004, *ON-AIR Project #032: The Silk Road*, 8-hour exposure.
Figure 24. Atta Kim, 2004, *ON-AIR Project #029: The Sex*, 1-hour exposure.

metaphysical issues. To some extent the creation of this work mirrors the processes of a Jackson Pollock painting, in that it encapsulates time itself. ¶ *In The Sex* (fig. 24), Atta represents the myth of Andromeda by taking a sex scene with an hour-long exposure in his studio. The trace of legs captured by light on a black background resembles our current concepts of the 'big bang' of the universe. This sex scene involving four lovers expresses the explosive form with misty circles, which create a scene of chaos. As Andromeda spreads out from a concentric circle, the 'big bang' of sex creates the galaxy, centered by the earth and a new world. Symbolically, it is the circle of the mandala and the shape of Eros. These two pieces examine Atta's fundamental interest in human existence, which is expressed in his words that 'Every object has the worth of being and ultimately it disappears' (Kim, 2006 p. 29). At first sight, Atta's statement seems to suggest that his work has been heavily influenced by Eastern philosophy and Zen Buddhist concepts of interconnectedness and transience. However Atta understands spirituality in more personal terms and, for him, the spiritual life has meaning and is manifest in a context much broader than that defined by any one specific religious doctrine.

The digital techniques he employs in these works enable the image to transcend mere documentary meanings and to add a somewhat fantastic atmosphere; the media technology in Atta's work serves as a tool to show the passage of time and its effect on the material. The next work therefore, focuses on the idea of the numinous as expressed by Atta's use of temporality through digital techniques in the selection of individual pieces, which collectively form the *ON-AIR* project, rather than exploring the numinous in the context of traditional religious discourse.. ¶ *Man of the World from Portrait Series* (fig. 25, see p.154),

consists of superimposed images (a trade mark of Atta's work) of 100 men from 100 countries, made over the course of three years (fig. 26, see p.155). ¶ The layered image appears at first glance to be a soft-focused portrait. The moment the viewer learns that it is the result of 100 different identities from 100 different nations s/he begins to imagine the diversity of skin tones and ethnicities encompassed in this composite image. In the course of the layering, specific characteristics and identities gradually attain ambiguity. As images of individuals from different groups accumulate on top of one another, boundaries collapse and a whole new identity emerges. Atta's series of portraits, such as *Korean, Tibetan*, and *Mongolian*, along with *Man of the World*, invite viewers to think again about the meaning of the individual and, by extension, of race and nation, as well as ethnicity and identity in this era of globalization. ¶ Through the combined methodology of superimposed image and long exposure, Atta has developed his perception that 'all that exists will disappear' into other aesthetic forms. These works were presented in his New York solo debut at the International Center of Photography titled Atta Kim: *ON-AIR* in which the *ON-AIR* project was presented in the form of transparencies placed over large light boxes. ¶ Through his *ON-AIR* project, Atta began addressing the question of duration and disappearance, existence and non-existence. The artist uses photography in order to contrast the medium's defining nature of representing, registering, and recording images with the laws of nature, which deem that all things eventually disappear. In doing so, he investigates and comments upon the realities of existence. ¶ From a technical perspective, Atta employs two types of processes in his work to realize this comparison between existence and non-existence. One depends upon the use of

extremely long exposures with a single 8 × 10 inch film – sometimes lasting as long as twenty-four hours – to create images that explore fundamental questions of time and perception, presence and absence. This is an old technique; early nineteenth-century pioneers of photography experimented with it, as have contemporary artists such as Hiroshi Sugimoto in his well-known shots of movie-house interiors taken while full-length films were in progress. The other technique Atta uses is to digitally superimpose many different images so that they are subsumed within a new composite image. ¶ Through these new digital devices, the artist layers anywhere from a dozen to a hundred separate images, to create a single composite picture, at once singular and multiple. Atta brings new digital techniques to this project in the manner in which he uses the two different processes of long exposure and superimposition to create ever more complex compressions and layering of time. Whilst this body of work still retains the traditional photographic characteristics of recording and representation, Atta believes that the traditional long-exposure technique is a powerful tool to express Orientalism and interrogate notions of identity, which include circumstances, politics, religion and sex. ¶ Atta's artwork may seem more distinctive for the ideas it explores rather than for the use of technology. However, the artist insists that, on the contrary, digitalization is an inevitable and significant dimension of his work, arguing that 'Digitization is a form of natural evolution as civilization is a definitive edition of nature. Human beings automatically evolve so as to make their lives more convenient' (Kim, 2007, p. 71). ¶ Digital technology as used by Atta in his photographic series enables an audience to imagine duration in ways that are radically different from our everyday experience. Multiple layering of imagery and the

use of digital technology allow the viewer to realize some uncanny visual concepts; concepts impossible to achieve through conventional photographic means. Atta himself argues that:

> Photography is generally understood to be one of the most realistic mediums among the art mediums, but I argue that ultimately it is not real. Because of its realistic characteristics, however, it can easily distort the representation of nature (Kim, 2007 p. 57).

Atta's work illustrates that digital technology is able to contribute to re-defining how we express the idea of the numinous, because the digital process used in Atta's work provided the artist with a different physical relationship to the medium. When Atta uses the traditional photographic medium, he cannot distort the natural order of things; but the digital work has made possible an experience that was no longer restricted in this way. He reconfigured the natural order to grasp the actual reality of nature; therefore, digital technology has offered him an insight into a numinous expression by overcoming the natural order of things. ¶ Manovich argues that the power of digitization lies in its ability to:

> Change our concept of what an image is – because [it turns] a viewer into an active user. As a result, an illusionist image is no longer something a subject simply to look at, comparing it with memories of represented reality to judge its reality effect. The new media image is something the user actively goes into, zooming in or clicking on individual parts with the assumption that they contain hyperlinks . . . (quoted in Hansen, 2004 p.10).

In themselves, artistic explorations of themes such as emptiness, light and time are not a new subject for creativity. Neither is the use of multimedia as a medium for artwork. What is distinctive is the way in which each of the artists discussed above combine their explorations

of these themes with multimedia technology to provide the viewer with a profound and contemporary experience of the numinous, unhindered by a conventional theological framework. In this sense I go a step further than media theorists such as Manovich in arguing that current artists such as Atta utilize both analogue and digital technology not only to transcend the traditional divide between art object and audience, and between art object and artist, but also to reintroduce the concept of spirituality in art and at best, facilitate experiences of the spiritual in a manner appropriate to the technological age of the late twentieth and early twenty-first century.

4.5 Mariko Mori: Utopia as a Spiritual Experience

The young Japanese artist Mariko Mori bridges traditional Japanese culture and history and today's cybernetic culture. From her earliest works, Mori has been an image maker *par excellence*, one who has embraced the possibilities of technology to create spiritual images that are strikingly alluring and surprisingly personal, each one extending the artist's singular understanding of the capacity for art to provide a spiritual dimension in Japanese culture. Her work is installed in a complex, high-tech media and spiritual temple, into which viewers are invited, one by one, for a magnificent audio-visual experience. This juxtaposition in Mori's work creates a complex experience that suggests the numinous. ¶ *Dream Temple* (fig. 27) was exhibited at the Fondazione Prada and was Mori's first collaboration with architect Marco Della Torre. Yumedono Temple[13] (the original *Dream Temple*)

13. Yumedono is one of the buildings on the site of Prince Shōtoku's private palace, Ikaruga no miya. The present hall was built in 739. The hall acquired its name from a legend that Buddha arrived as Prince Shōtoku and meditated there. Various images of this temple are available on the Wikipedia website.

Figure 27. Mariko Mori, 1999, *Dream Temple*, Installation view at Royal Academy of Arts. London.

was the first Buddhist temple and meditation space in Japan. Prince Shōtoku built Yumedono in his residence in Nara as a simple, personal meditation space for studying the Buddhist sutras. This remarkable re-creation of the eighth-century Yumedono Temple in Nara, Japan, provided the elegant framework within which Mori created an internal core, a kind of private grotto, in which she projected a video sequence of embryonic light forms. In this installation, Mori deliberately juxtaposed media technologies with architectural space to guide the visitor through a temple installation where the spectator might fall to their knees in prayer. ¶ Mori's *Dream Temple* also refers to a state of religious enlightenment in Buddhist practice, pointing toward the increasingly spiritual focus of her work. This architectural space is a cyber transposition symbolic of an ancient typology. Building upon art history's landscape tradition, Mori attempted to capture the more elusive qualities of the environment, and viewers are confronted by a disjunction between a spiritual vision and a high-tech artwork. Technically, the digital technology (Western processes) coalesce in the scenery, blending Japanese culture and history and revealing the existence of a numinous sphere. This collision produces complex feelings, numinous feelings, from the realization that multimedia technology has the potential to disorder our spiritual experience and to distort, disturb and control our usual understanding of spirituality even when virtually created. However, even though I have emphasized the role that multimedia technology plays in expressing the idea of the numinous, in *Dream Temple* the exploration of the numinous transcends the use of technology itself. While Mori's *Dream Temple* is numinous, the real Yumedono temple too, being a perfect meditation centre, is also a numinous place. ¶ Through this *Dream Temple* installation, Mori

creates a numinous experience in the gallery by combining an architectural object with multimedia technology. Mori combines mediums in such a way as to transcend the prosaic associations of both the architectural object and technology so that the object is reinvested with a numinous feeling, which lies beyond the conventional symbolism of the object, transporting the viewer into an altogether different realm.

¶ The strengths of both the object and the technology become apparent and enhance one another to create a more powerful and open spiritual experience. The combination of media enhances our sensual perception of the spiritual quality of the object. It is successful because of the manner in which multimedia technology can intensify the metaphysical potential of the object – a potential which is always unpredictable in terms of visual outcome. The image is continuously changing, and each manifestation is dependent upon the specific environment in which it is generated. The point is that what we see through the projected temple is not the same as that which is gained from the temple without the video projection. Therefore this collision of technology and installation object transcends the physical experience and propels the viewer into a metaphysical, numinous realm. Mori's video installation relies for its inspiration on both Eastern and Western art, the history of art and religion, past and present. She utilizes media technology as a vehicle to deliver the numinous feeling in this context.

¶ Another work of Mori's which depends upon multimedia technology and its capacity for active interaction is her spectacular project *Wave UFO* (fig. 28). First seen at the Kunsthaus Bregenz in February 2003. If *Dream Temple* was a reinterpretation of a Buddhist past, *Wave UFO* examined its futuristic Utopia. *Wave UFO*'s programme allows three participants the opportunity to enter a state of harmonious uni-

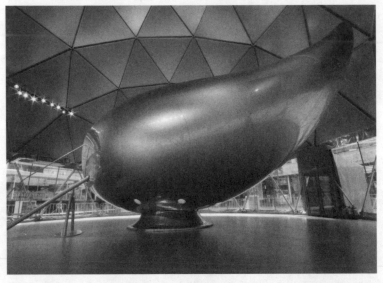

Figure 28. Mariko Mori, 2003, *Wave UFO*, Installation view at Victor Pinchuk Art Centre, Kyiv.

ty. As such, the philosophical underpinnings of *Wave UFO* are deeply rooted in the Buddhist idea of connectivity (or interconnectedness), wherein each individual element of the universe is a fundamental part of the greater whole. This idea was discussed in the previous chapters, in the context of 'overpowering' and 'creature-consciousness', experienced as an object over and against the self. We saw there Otto's belief that 'in contrast to "the overpoweringness" of which we are conscious as an object over against the self, there is the feeling of one's own submergence, of being but "dust and ashes" and nothingness' (Otto, 1959 p. 20). ¶ At its first presentation in the Kunsthaus Bregenz, this transfer of energies was palpable. *Wave UFO* seemed to have landed gently on the third floor of the gallery, bafflingly complete and myste-

riously lacking human assistance, despite its dimensions of 5 × 11 metres and its weight of 6.5 tons. The reflection of the scintillating silvery-blue and rose-coloured surface, the idiosyncratic mixture of technoid logic and a soft, fishlike form, the soundless swinging of the eyelike door, the intimate mystery of the cathedral like capsule – every detail irrefutably contributed to the totality of its perfection. All the tell-tale signs that might betray human intervention had been meticulously erased – as if the work had created itself. Three visitors were admitted at a time, and were instructed by white-robed attendants to remove their shoes. They were then hooked up to electrodes designed to monitor their brainwaves. A set of white plastic headrests allowed each visitor to lie down in comfort. The light show that ensued was part interactive bio-feedback and part graphic animation. For the first three minutes, visitors' brain impulses controlled the colours projected on the curving ceiling. Agitated thoughts turned a pair of elliptical orbs red; 'wakeful relaxation' turned them blue; and a dreamlike state, produced a yellow hue. Theoretically, if all three visitors were on the same wavelength, a ring of light would appear, although a technician hidden away in a nearby kiosk confessed that he had never seen this happen, nonetheless Mori's work feels sincere in its utopian ambitions.

¶ The issue of utopia may provide the clue for today's globalised numinous reality since it is currently a topic of social debate in the media and the world around us. Mori has presented her vision, which sees all living creatures as being connected in an ideal world, in massively futuristic form, creating at the same time a contemplative space in which others can partake of her vision. What we have before us, with its brilliant surface and seductive, floating shape is an extraordinary work of art which is partly a large-scale sculpture we can walk

into, partly biomorphic architecture, and partly a spiritual space. In interviews, Mori espouses a faith in universality, purity and progress, modernist notions that have become suspect in these darker times. Mori points to Buddhism, Shintoism and other Asian philosophies as sources for this hope and she argues that many ancient civilizations' belief systems relating to utopia are expressed in her work. However, *Wave UFO* also suggests curious convergences with the numinous experience. Despite the specific Japanesque trappings of much of Mori's work, she also seems to be touching on more widespread contemporary concerns about loss of personal interconnection, anxiety about the role played by technology in modern life and the fear that humanity is merging with machines. Is there a convergence between Buddhism and digital technology? Is the Web a model of universal consciousness? Can we leave the body behind and find connection at the mental level? ¶ The strangeness or un-naturalness in Mori's work can be understood as one of the main characteristics of the numinous. In particular she has maximized the functions of multimedia pushing its capabilities to the limit; focusing on its properties of interaction while simultaneously inducing a sense of un-naturalness and strangeness in the image. The use of multimedia technology coalesces in the scenery, blending the Japanese temporal and cultural boundaries. Moreover, by attempting to merge the boundaries between the spiritual realm and the real world, Mori aims to reveal the existence of a numinous sphere which draws upon, but ultimately transcends, the specific and limited dimensions each of us inhabits individually. For visitors experiencing *Wave UFO*, entering the pod resembles an experience of returning to the womb to be reborn. When it's over, there is no question that the momentary escape from reality has been restorative. In Mori's utopian vision, technology appears as

mankind's saviour which leads us through a mythologized and dreamy vision of the numinous. In conclusion, Mori's intention was to create a utopia; an ideal place for the history of Oriental and Western thought to converge through technology. Hence, *Dream Temple* and *Wave UFO* both function as a passive and unconscious journey into becoming: essentially an encounter with the numinous. ¶ In comparison with *Dream Temple*, multimedia technologies are more actively utilized in *Wave UFO*. This development profoundly enhances the virtual environment, such that the numinous can be realized more directly than in the previous mediums Mori had used such as photography, sound, video and oil painting. In *Wave UFO*, multimedia opens up new possibilities of engaging with sensor devices, for example, infrared sensors, sound sensors and light sensors. ¶ Arguably, they have enhanced virtual reality and can present new possibilities for spiritual experience. For instance, Multimedia technologies in Mori's work have provided broader insights for artist in her attempts to create interactive settings for the presentation and contemplation of spiritual dimensions. Technology has enhanced virtual environments in an even more profound manner enabling the numinous feeling to be realized more in interactive settings. By utilizing multimedia technologies, Mori enhanced the virtual experience of the numinous environment and re-created the experience in a gallery or public space.

4.6 Jungu Yoon: Towards the Numinous Space

Figure 29. Jungu Yoon, 2007, *Stroke*.

This section is an account of the journey from two-dimensional to three-dimensional approaches to evoking the numinous, and takes further the exploration of the Eastern notion of the concept. The first piece of work discussed here is entitled *Stroke* (fig. 29) and is the outcome of re-working an earlier print *Kumgang Jeondo* by digital erasure. In the original *Kumgang Jeondo* print, images were deployed in a realistic manner although evoking a multiple viewpoint in the style of traditional *Shanshui* painting. However, in the re-visited work *Stroke*, I departed from my earlier realistic manner, turning away from experiments with perspective in order to experiment with expressing the numinous feeling through the theme of emptiness or the void.

While this series revisits my previous image of *Kumgang Jeondo*, it does so through a significantly different approach. In this instance the images, again created in Adobe® Photoshop®, try to replicate the sense of erasure and smudging by using the mouse. During the process of making or re-making this piece I observed how this kind of techni-

cal application was reminiscent of the slow motion of brush stroking, hence, the naming this work *Stroke* seemed an entirely logical choice. Although the mouse strokes took only between one and two seconds to physically enact, it took over a minute for the actual data to be processed. The slowness of this procedure evoked an image of a live organism moving across the screen, while forming unexpected movements and results that were nearly impossible to predict. Observing this process was extremely interesting, and in order to capture this sense of mystery and unpredictability, I documented the smudging process with around 60 jpeg image files formed with a time sequence. Applying multimedia to any computer-based application usually makes it easier to operate or convert the image-based medium. Through this documentation process both the moving and still images have the potential to produce imagery in any direction and dimension in an open digital environment. This digital process of documentation produces one strong image because of the linkage between the images. On the other hand, those sequenced images can be comprehended as an individually transformed image. Without any electronic plug-in, the documented images can be modulated, thus allowing forward and backward movements and figurations that are reversible and can be endlessly repeated in feedback to the viewer. ¶ All in all, I generated 60 complete images in this manner. However, for the group exhibition titled *Digital and Physical Surfaces* (see fig 31), I selected only four images, keeping to the sequential order and presenting them as a single picture. Although the four images were each produced at different times, there are inherent visual clues which link one with another and create the sense of a coherent whole, rather than four separate images. Through this work I was consistently searching for a method of using

media technology itself as a vehicle to create numinous experience. In particular, I was exploring concepts of non-existence, of emptiness and of limitlessness in order to access a sense of the numinous. ¶ As previously noted, in *Shanshui* painting, the voids were meant to suggest the mystery of emptiness, based on Taoist speculations about the significance of the non-existent. As such, a void was never merely atmospheric but rather a vehicle for engendering a spiritual encounter, something akin to the numinous experience. Thus the erasing process I deployed was influenced by a unique cultural conception of the East Asian concept of the void. I applied this spiritual emptiness to the *absence* of brush and ink whereas the actual *Shanshui* painters express the concept of emptiness through the presence of brush and ink. Clearly, I did not create the void with the traditional medium of brush and ink but rather attempted to convey this feeling through digital media. To be precise, the spiritual quality of *Shanshui* painting was re-applied the idea of the void in a contemporary setting. Every time a stroke was executed through the mouse, the image was deleted and smudged, which is the direct opposite of the process that takes place in the strokes of *Shanshui* painting where every stroke fills the empty spaces. Thus my practice is ultimately a reversal of *Shanshui* painting. In reversing this idea, my aim was to restate the formal meaning of emptiness in *Shanshui* painting using modern methods and, in doing so, demonstrate that digital technology used to engender the empty space in *Stroke*, is equally as capable of articulating a sense of the numinous, and has the potential to enhance the vastness or infinite qualities of the spiritual, with the same gravity and success as traditional forms of Eastern painting. ¶ With the *Stroke* series of digital prints, I was concerned with the broad issue of opening up the wide range

of spiritual perspectives and bringing out further issues related to the concept of the numinous. In *Stroke*, I deliberately employed digital media not only to re-introduce or appropriate pre-existing imagery but also to inject new meaning by creating a significantly different visual encounter through technological manipulation. The process of erasure and the consequent empty aspects of the image are symbolic of something greater. ¶ It is significant that the digital encoding process involved in the mouse stroke is not tangible and measurable until it is printed on paper. In the digital format, images are neither on paper (or canvas) nor in the head alone. They do not exist by themselves but they take place through monitor (or screen). As such, it might be argued that they occur via transmission and perception rather than via mental images or physical artifacts. ¶ In his essay 'The Discrete Image', in which 'discrete' signifies a digitally encoded image, Stiegler has proposed a distinction between analytic perception and *synthetic* perception. He aligns analytic perception with technology or medium and synthetic perception with the mental image that results in our perception, arguing that:

> Our images do not exist by themselves or of themselves. They live in our mind as the 'trace and inscription' of images seen in the outside world. Media constantly succeed in changing our perception, but we still produce the images ourselves (Derrida and Stiegler, 2002 p. 145-6).

He goes on to suggest that media are expected to be new, while images retain their original life. Images take residence in one medium after another and in this sense resemble nomads. Stiegler's concept of the migration process of images raises the interesting question of what distinction multimedia has in presenting the idea of the numinous compared with traditional mediums such as oil and watercolour paint-

ing. In order to pursue this line of thinking purpose to ask this question, I was prompted to explore the use of various media technologies more actively in my creative practice. The following works indicate this development. ¶ A sculptural installation entitled *In the Temple* was also presented in the exhibition *Digital and Physical Surfaces* in 2007 (figs. 30-31). The piece comprises 20 sheets of transparent acrylic, each 1 cm thick. They are joined together to form a cube-shaped acrylic sculpture. Inserted between each plate are sheets of printable transparent acetate bearing a single image of a Greek temple. Collectively this resulted in the production of a three-dimensional image of the temple. From the front, the temple is visually clear but, owing to the slight opacity of the acrylic plates, the temple image fades, as the image appears to be increasingly out of focus, like a blurred photograph. In addition, a digital image of jellyfish, recorded in Busan Aquarium in 2004, is projected through the acrylic box to create the sensation of biological movement. The 20 separate plates and acetate surfaces absorb this five-minute jellyfish film. The overall effect created by the work is of a three-dimensional illusion, in which jellyfish float around the empty space of a temple. The slight opacity of the acrylic sheets helped to reduce the visual clues in this projected image as to how it is constructed, and this effect produced a greater sense of mystery. Moreover, the misty effect generated through the video projection made the three-dimensional image of the temple look even more mysterious. The intention behind introducing mist into the landscape was to add a further veil, and therefore to enhance the mysterious and spiritual qualities. My initial aim in this sculptural projection was to create a kind of equivalent virtual experience of natural elements such as fog and mist by using multimedia technology.

This installation can be considered as an extension of the themes and issues developed in my previous examination of the void, but using a different approach. In this work I use DVD and a video projection for the first time. The expression of emptiness of *In the Temple* is closely associated with the idea of emptiness in Nam June Paik's *Zen for film* (fig. 18). My analysis of the imageless *Zen for Film* is one way of describing the numinous. We saw earlier how the removal of one subject in Paik's film allows for the appearance of another 'wonder'. I have utilized digital media technology as a vehicle to deliver the spiritual emptiness that Paik examined. ¶ I used the public exhibition of the work as a medium for obtaining audience feedback as to the efficacy of this strategy. Written comments recorded by visitors to the exhibition suggested that the use of the jellyfish film is effectively employed. A sculptor commented that the

> sculptural piece, along with the projected image evoke in me a kind of mysterious experience. I am especially enthralled by the three dimensional look and the organic movements of the image which evoke spiritual elements and immanence.

He added that the jellyfish image penetrating through the temple created a wonderfully virtual experience for many viewers. However, to my surprise, the potential for engendering numinous experience was found somewhere I had not initially considered. The acrylic plates reflected quite a lot of light, and these reflected images created a unique holographic after-image, which was an unintended effect. Powerful reflections on the wall appeared as a mirroring effect of the projected video images. Reflecting the biological movements of jellyfish, the surface of the acrylic plates mirrored corresponding shapes, but produced blurred and distorted images. ¶ Much of the feedback dur-

Figure 30. Jungu Yoon, 2007, *In the temple*.

Figure 31. *Digital and Physical Surfaces* Exhibition, 2007, Triangle space, London.

ing the exhibition indicated that it was the reflections that created the numinous mood rather than the actual sculpture. Exhibition feedback and individual interviews supported this analysis; almost half the viewers consulted reported that the aspect of reflection in this work was an important numinous element. And a quarter felt that both the sculpture and the reflection were significant. It is interesting to note that the reflections on the wall were created as much by natural phenomena as by digital media. This raises the question as to whether natural reflection is equally as effective as media technology in pursuing a sense of the numinous. If so, this alters my original hypothesis and line of investigation, which was based exclusively on the appropriation of digital media technologies to express numinous feelings. As such, it appears that the ability of my work to create numinous experiences is not limited to the use of media technology. If the numinous elements arise as the result of a symbiotic relationship between a natural phenomenon and technology, it means that numinous feelings are not only accessed or created (or even better, accessed and created) specifically by the use of media technology. Thus, while the numinous can be expressed by various means, new media is not necessarily an essential element in opening up these possibilities for exploring the numinous through contemporary art. ¶ The coincidence of discovering numinous expression through reflection has greatly influenced my work since the *In the Temple* installation, and it was one of the main reasons for exploring the concept of reflection in the next work, *Radiant*. ¶ This work complements the previous project *In the Temple* (fig. 30); it comprises a highly reflective object combined with the video image from the projector. In this project, *Radiant* (fig. 32, see p.157), the intention was to build upon the earlier exploration of the numi-

nous through the reflection created by a video projector, but the two works differ significantly. For example, with *In the Temple*, reflection was obtained coincidentally, whereas in *Radiant*, light and reflection were intentionally adopted as a main avenue for pursuing a sense of the numinous. Also in the later project, a candle-flame-shaped copper sculpture is the material basis of the work in contrast to the acrylic plates that make up *In the Temple*. At this point I was searching for the best possible reflective effect, achieved here by polishing the copper sculpture. Moreover, the purpose of using this flame-shaped shiny copper sculpture for *Radiant* was not to limit the video image to the rectangular box, but for it to extend beyond the boundaries of the box in an unlimited manner that allowed various unexpected effects. For this reason the copper sculpture has been described as 'illuminated'.

This sculpture was created at a silversmith's studio with a single sheet of copper approximately 2 mm thick. It was made by the hammer-raising technique, and the surface was highly polished in order to get the maximum reflection. ¶ My inspiration for this work derives from Bill Viola's video installation *Stations* (fig. 22). In this video work, discussed earlier, Viola utilized a mirrored projection surface to emphasize issues of spiritual significance in his work. Viola deliberately juxtaposed his spiritual exploration of light and the human figure with its reflection, leading the viewer to become fascinated with the images. As noted earlier, historically, the theme of light has been especially significant for conveying various aspects of spirituality and religiosity. In the modern era media technologies have opened up new avenues for exploring the relationship between light and spiritual concerns. One particularly effective method has been the use of light as captured on a screen in still photography, film and video, as discussed in

the Viola case study. ¶ *Radiant* also has the potential to provide viewers with an experience of the numinous. In this project, I created a fast-paced, dazzling video output using MD8, a computer software program, which is generally employed by video jockeys in nightclubs. The images of dread and horror used for this video were sourced from various origins such as Goya's horrific print books, roadside memorial photos, dead bodies and grave photographs. The software deforms these horrific images to the extent that the significance of the disturbing content is diffused and transformed as they are reflected off the sculpture. Consequently, what the viewer actually perceives is not a vision of terror and trepidation but simply a single beautiful manifestation of light and luminosity. ¶ Through the *In the Temple* and *Radiant* installations, I aimed to create a numinous experience in the gallery by combining a sculptural object with media technology as Nam June Paik achieved with his 1974 *TV Buddha* installation (fig. 17, see p.151). We have already seen how Paik combined a sculptural object (an antique Buddha) and media technology (TV) to transcend the prosaic associations of both the sculptural form and the media technology, so that the object is reinvested with a numinous meaning that lies beyond its conventional religious symbolism, transporting the viewer into an altogether different realm. In Paik's work, technology and object enhance one another to create a more powerful and open spiritual experience. Adopting a similar approach in my own work, *Radient*, the sculpture alone gives us far less than the sculpture combined with the video projection. ¶ The combination enhances our sensual perception of the spiritual quality of the object because of the manner in which multimedia technology can intensify the reflective potential of the work. Therefore, this potential is always unpredictable

118

in terms of the visual outcome. As such, reflection functions in my work as a symbol of the numinous in that it is uncontrollable and each manifestation is dependent upon the specific environment through which it is generated. ¶ In each instance, viewers are confronted by a disjunction between a video projection and a sculpture, and at the same time, a combination of electronic techniques and the reflected images which are generated incidentally as a kind of by-product. The point is that what we see through the projected sculpture is not the same as what is gained from the reflections on the wall. On the one hand this type of work might be described as a sort of 'high-tech' art, but on the other hand, the reflection on the wall is also a natural phenomenon. Therefore these collisions between technology and natural phenomenon transcend the physical experience and propel the viewer into a metaphysical, numinous realm. ¶ In order to look at how multimedia opens up new possibilities of encountering the numinous for contemporary artists, I focused on the ideas of the numinous as represented by video artists such as Nam June Paik and Bill Viola, in order to go beyond the two-dimensional use of media technology, which had characterized my previous digital prints. ¶ In terms of media usage, the biggest difference between traditional media and multimedia is that multimedia turns the viewer into a far more active participant than traditional media allows. As a result the numinous experience is not just something a subject observes from a distance. Multimedia technologies build into the artwork a more active role for the viewer, which can generate a sensual experience of the numinous, as opposed to a second-hand, intellectual contemplation of spiritual issues in the artwork. Therefore, multimedia is able to re-conceive the numinous feeling in an even more profound manner than a tradition-

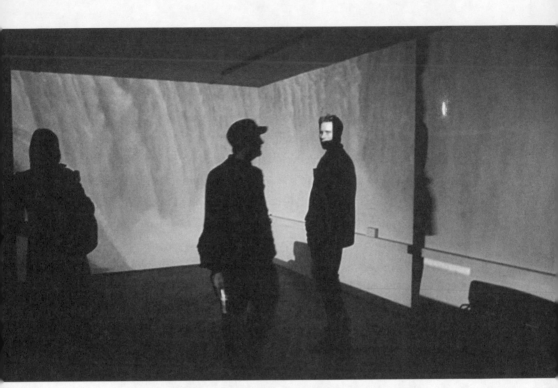

Figure 33. Jungu Yoon, 2008, *The Fall project*, OXO Bargehouse, London.

al visual medium such as oil painting or watercolour. This is not to claim that media technologies are either absolute or essential for creating numinous modes of experience; they do not necessarily take precedence, or function at a superior level to, other more traditional pre-existing media. It is simply to emphasize that media technologies have reshaped and extended the possibilities of the physical presentation of numinous experience. As Hansen states: 'Technologies alter the very basis of our sensory experience and drastically affect what it means to live as embodied human agents' (Hansen, 2004 p.6). Hansen argues that art underwent a fundamental metamorphosis, losing its status as a unique object tied to a single time and place along with the media technology convergence. I argue that technological convergence can expand, diversify and further enrich our spiritual experiences because media technologies can expose all manner of imperceptible affective processes to the viewer, and mediate what is visible to natural perception. ¶ Through questionnaires and surveys, and the collation of written comments and audience interviews carried out during the exhibition of the works discussed above, I conclude that a collision between media technology and the sculptural object is a significant means by which to stimulate and facilitate encounters with the numinous. ¶ These findings lead to the conclusion that in order to heighten the numinous experience using a virtual artwork, media technologies needed to be more actively combined. In consequence, in 2008 I embarked upon a self-reflecting project entitled *The Fall Project* (fig. 33). ¶ *The Fall Project* centres on manipulated images from a video of the Niagara Falls, recorded on a visit to Canada in 2007.[14] The intention behind this piece was to incorporate all the various numinous elements examined through the whole of my practical re-

14. The piece was presented at OXO Bargehouse, London in 2008 as part of Korean group show titled *4482*. The exhibition was curated by Sunhee Choi and sponsored by The Korean Cultural Council. It can be regarded as the final piece of my research.

search. Several multimedia devices were used. For example, the work required three video projectors, three DVD players and 5.1 channels of audio track, which broadcast from various speakers the sound of dripping water. The sound track was especially important in enhancing the virtual reality effect of the work. These digital devices were installed as single piece of work in a dark room measuring 5 m × 9.3 m × 2.5 m. Two mirrors (each measuring 50 cm × 70 cm) were installed to amplify the video image from a short distance. The mirrors were necessary since directly projecting the film without amplification limited the maximum image size to only half the size of the wall. Three infinite loops of waterfall images on DVD were projected on two sides of the wall. ¶ The overall effect made the waterfall image appear as a single panoramic scene accessed from one viewpoint when, in actuality, each film had been recorded from different angles and locations. When visitors entered the room, they were confronted with a huge space comprising a virtual waterfall with the surrounding sound of dripping water. ¶ There were two main reasons for choosing the waterfall as a central feature. The first concerns the significance water holds in terms of religion and spirituality. As I have already outlined, in order to visualize the numinous in art, natural elements such as fire, water, mist, mountains, rocks and light are frequently selected to convey this spiritual state. The symbol of a waterfall is a recurring theme in many religious traditions and spiritual contexts. For instance, Christian churches have an initiation ritual involving the use of water. Baptism is a symbol of liberation from the oppression of sin that separates us from God. In Hinduism water also has a special place, because it is believed to have spiritually cleansing powers. To Hindus all water is sacred, especially rivers, and there are

seven sacred rivers (Alter, 2001 p. 3). Water is an omnipresent theme among both the popular and the intellectual beliefs and practices of ancient Asia, such as animism, Shintoism, shamanism, Taoism, Zen Buddhism and the symbolic geography of Wind-Water (*Feng-Shui*). Before the advent of typical Chinese landscape art, Chinese, Korean and Japanese animistic beliefs conceived of the numerous forces of nature (oceans, rivers, lakes, waterfall, rocks, tall trees, mountains and sacred animals) as phenomena that inspire fear. To the people of the East, nature, especially in the form of water, holds an ambivalent fascination, which combines a sense of fear with spirituality. In Chapter 1, I outlined how for Otto the numinous involves both feelings simultaneously. Hence, in order to introduce these same symbolic elements into my own practice and thereby create the numinous feeling in a gallery space, I selected the waterfall as one of the most effective and appropriate subjects from the various natural phenomena. ¶ This idea that the numinous arises in conjunction with natural elements is a key tenet of Eastern *Shanshui* paintings. As the traditional *Shanshui* painters argued, water, and in particular, the waterfall, functions as a medium that reflects humanistic experience of supernatural or mysterious realms. Therefore, it was my aim in this installation to create a virtual waterfall environment that embodied the same potential as Chinese traditional painting. However, although the waterfall project shares similar objectives with those of *Shanshui* painters, it adopts a different approach to achieving them, in particular, in the way the image and the sounds collide. The waterfall was intended to create a contemplative space in the gallery. As such, a viewer might experience the sublime via a nature scene, or encounter the numinous through the meditative ambiance and physical environment. My intention was

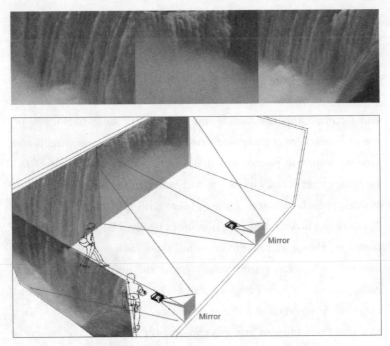

Figure 34. Plan for *The Fall project*.

to create both sensations in the audience. I intentionally used dripping-water sounds for this project rather than recording and using the original and authentic waterfall sound of the Niagara Falls. The manipulation involved in the 5.1 channels of dripping water sounds boosted not only the virtual experience but also created a meditative environment, whereas the original waterfall sounds were loud and distracting. The simpler, quieter water sound induced a peaceful and calm contemplative ambiance. ¶ My intention was to construct a meeting space that juxtaposed natural phenomena and media technology to transform the art museum or gallery into a place where the

numinous might be encountered. The video showing large amounts of water falling, together with the surrounding sound of dripping water induced feelings of confusion in viewers. ¶ The complex feeling created by the collision between technology and nature can produce a numinous feeling because their juxtaposition presents the audience with the realization that multimedia technology has the potential to disorder our sensory experience and to distort, disturb and control our usual understanding of natural phenomena, even when virtually created. Art critic Ku Yeon Huh (2008) commented that the large scale of the waterfall was expressed well, but felt that the sound would be much better with a waterfall sound, augmented in volume with a grand, sublime effect: 'I am fascinated by the virtually created magnificence of the waterfall. However, the water sound should be louder and greater than the more subtle sounds of dripping water. This collision of sound brings a reluctant or insufficient feeling to my mind'. Other observers have made similar comments, stating that the water sounds were insufficient, unfulfilling, and lacking in emotion. Although these opinions may appear negative from the usual perspective, rather than coming to the conclusion that the sound used was ineffective, I interpreted them as an indication that my work had succeeded. Through the use of new media I had achieved my intention of providing the viewer with a different experience from normal everyday life by engendering a mysterious feeling. ¶ The aim of this work was never focused on aesthetic concerns such as the beauty or the magnificence of nature. ¶ I intentionally subverted received understanding of natural phenomena to concentrate and emphasize the numinous elements behind nature. More specifically, I selected two elements in order to examine how the numinous can be expressed

through multimedia technology, namely; reproducing a grand natural element with the use of technology and adding a different element to the usual perception of nature in order to imply a numinous existence. I believe that this has created a complex experience for the viewer. ¶ In comparison with my previous works, multimedia technologies have been more actively utilized. This development profoundly enhances the virtual environment such that the numinous feeling can be realized more directly than in pre-existing media, such as oil painting, watercolour, sculpture and photography. In this work, multimedia opens up new possibilities for presenting the numinous. First, the video projector enabled the production of a huge waterfall image and permitted the alignment of the image size with that of the gallery wall. Secondly, multimedia technology facilitates the creation of what is beyond of the sphere of the usual or familiar. For instance, viewers confronted by the incongruous combination of the waterfall image and water dripping sounds, experienced wonder and astonishment. During the exhibition I observed people walking around the room attempting to trace the surrounding sound. Some touched the wall to grasp the projected fall image, others leant, stood or sat in the room to meditate, and some contemplated the room from a long distance to see the whole vista of the fall. In this way the gallery space did become an interactive site in which an audience was able to encounter the numinous. The complexity and confusion, accompanied by extreme reactions of attraction or repulsion, triggered psychological responses that favoured an encounter with the numinous.

Understanding the Numinous

The term 'numinous' enables us to clearly isolate the idea of spirituality from its traditional religious connotations. It is defined above and beyond the usual religious context and as such, overcomes the barriers created by specific religious doctrines. ¶ Otto asserts that the numinous cannot be expressed by means of anything else because it is a primary and elementary force that governs our psychic life. Eliade argues that not all faiths or modes of spiritual expression understand the numinous as a supernatural concept; some, he suggests, conceive the numinous as an experience accessed through earthly objects – for instance, by manifesting the numinous, a stone becomes something else. The stone reveals itself as numinous and its immediate reality is transmuted into a supernatural reality. It is evidenced in the early stage of religious development, when people were drawn by the fascinating power of the natural or daemonic–divine object. Such objects may appear to the mind as objects of dread, but at the same time they possess alluring qualities and function as potent charms and spells.

Eliade concludes that a sense of the numinous often arises from this complex collision between inner reality and natural objects. However, I suggest that it is not only these natural objects that have the potential to convey or express the numinous. Artists also have the means at their disposal to invoke numinous feelings. ¶ Multimedia can stimulate our metaphysical understanding. Paik demonstrated that media technology has the potential to provide the viewer with a vir-

tual experience of the numinous. Although the scientific approach to the concept of time has overturned the once prevalent ancient philosophical concept of time, editing devices and video techniques offer endless possibilities for the formal structuring of time in visual presentations. Multimedia has provided the viewer with the circumstances to access the out of the ordinary, or that which is beyond the natural order of things. Therefore, the numinous is often produced by the quality of multi-media, which functions as a uniquely new attraction or fascination in contemporary culture. ¶ Multimedia technology has also provided broader insights for artists in their attempts to create interactive settings for the presentation and contemplation of spiritual dimensions. It has enhanced virtual environments in an ever more profound manner, enabling numinous feeling to be realized more interactively than in pre-existing mediums. In *Five Angels for the Millennium*, Viola employed multimedia technologies to draw our interest and curiosity towards the spiritual world. He demonstrates that multimedia technology is not merely a vehicle for the reproduction of real life but can also deliver sensations indicative of a spiritual sphere beyond the physical world. Although Viola refrains from directly using the term 'numinous', I regard this spiritual sphere beyond the physical world as a reference to the numinous experience. However, even though I have emphasized the role that multimedia technology plays in expressing the idea of the numinous, the exploration of the numinous transcends the use of technology itself. This argument is examined through Atta Kim's work, where old and new techniques are employed in order to create the layering of time. As such, Atta's artwork may be more significant for the idea it explores rather than for his use of modern technology. ¶ The primary aim of my own work

has been to utilise multimedia technologies to enhance the virtual experience of the numinous environment and to recreate the numinous experience in a gallery space. My emphasis has been on the relationship and efficacy of the works both as a linked group and as an overall complete project. Multimedia artworks turn the viewer into a more active user than do traditional mediums. They interrelate in many ways with surrounding media, and involve and interact in dynamic processes with the viewers. ¶ Through multimedia technology, the expression of the numinous is not simply something which a subject looks at; rather they take the viewer more actively into the numinous experience – for instance, in my final work discussed here, *The Fall Project*, which is a vehicle to deliver an experience of the numinous to viewers through more interactive means. In this project, multimedia technology was used as a pro-active medium in order to challenge pre-conceptions of how contemporary art can express the idea of the numinous. ¶ Traditional media tend to maintain their specifically fixed setting or temporal spatial relationships, and although this aspect has not been adequately examined here, it is an ongoing part of my creative practice. For instance, the waterfall project can be installed not only in a museum or gallery space but also in a variety of alternative environments, such as public buildings, temples, churches, and possibly in exterior contexts, which all create different settings for encountering the numinous. ¶ In analyzing the numinous elements represented in both Western art and traditional Eastern landscape painting. Although those familiar with Eastern art history may recognize a convergence of interests between the themes and purposes of my work and a traditional academic approach that has an established historical development rooted in ancient *Shanshui* painting, my main

intention has been to tackle the subject from a contemporary view-point, emphasizing both the practical and spiritual dimensions of the numinous. In this way, I hope that such practice-led research may be of interest not just to people with an inclination towards the spiri-tual in art, but also to those already experimenting with multi-media technologies and open to expanding their horizons. ¶ In sum, con-temporary artists understand and express the concept of spirituality in far broader and more personal terms than has previously been the case. In so doing, they are considerably less likely to demonstrate alle-giance with any one specific religion or religious doctrine. These shifts in spiritual understanding, and the subsequent attempts of artists to visually represent that understanding in Western art history, demon-strate that the process of expressing or approaching spirituality in art is a constantly changing one. My analysis has shown how the idea of the numinous is important and relevant in understanding the idea of spirituality in contemporary art.

List of illustrations
Bibliography

List of illustrations

Figure 1. *Sung Hwang Dang* – stacks formed of stones, date unknown.
Bukhansan, Seoul
Photo: © National Parks of Korea

Figure 2. *Lung-Men Caves*, The late Northern Wei and Tang Dynasties, 316–907
Henan
Photo: © Pratyeka, London

Figure 3. *Fengxian-Si*, 672-675
A seated Buddha more than 35 ft (10.7 m) high
Henan
Photo: © by courtesy Yichang China Travel Ltd

Figure 4. Chris Ofili, *The Holy Virgin Mary*, 1996
Paper collage, oil paint, glitter, polyester resin, elephant dung on linen, 243.8 x 182.9cm,
Sensation exhibition, 1999, Brooklyn Museum of Art, New York
© the artist

Figure 5. Andres Serrano, *Immersions (Piss Christ)*, 1987
Cibachrome print on Plexiglas, 59.7 x 40.6 cm
© the artist, Photo: © by courtesy Yvon Lambert Gallery, Paris, New York

Figure 6. Bill Viola, *The Messenger*, 1996
Video/sound installation,
Installation view from Durham Cathedral, Durham
© the artist, Photo: © by Kira Perov

Figure 7. Damien Hirst, Installation *Romance in the Age of Uncertainty*, 2003
White Cube, Hoxton, London
Photo: Stephen White
© the artist and Hirst Holdings Limited / Photo: © by courtesy White Cube / DACS London

Figure 8. Olafur Eliasson, *Weather Project*, 2003
Turbine Hall, Tate Modern, London
Photo: © by Jungu Yoon

Figure 9. Francis Bacon, *Painting*, 1946
Type Oil on linen, 198 x 132 cm
Museum of Modern Art, New York. Bought in 1948
Photo: Prudence Cuming Associates Ltd
© by The Estate of Francis Bacon / DACS 2010, London

Figure 10. Damien Hirst, *A Thousand years*, 1990
Steel, glass, flies, maggots, MDF, insect-o-cutor, cow's head, water, 210 x 400 x 215 cm,
Charles Saatchi, London
Photo: Roger Wooldridge
© the artist and Hirst Holding Limited / DACS, London

Figure 11. Damien Hirst, *The Tranquility of Solitude (For George Dyer)*, 2006
Glass, steel, porcelain, plastic, pewter, bakelite, resin, chrome, Panerai® watch, razor blade,
sheep and 5% formaldehyde solution, 84 x 60 x 30 inches x3 tanks
Gagosian gallery, London. Photo: Prudence Cuming Associates
© the artist and Hirst Holding Limited / DACS, London

Figure 12. Antony Gormley, *Blind Light*, 2007
Installation view, Fluorescent light, water, ultrasonic humidifiers, toughened low iron glass,
aluminium, 3200 x 9785 x 8565 mm,
Hayward Gallery, London
© the artist, Photo: © by Stephen White, London

Figure 13. Mark Rothko, *Black, White, Blue*, 1963
Acrylic/paper/panel, 74.9 x 55.2cm,
Christie's London, London
Photo: © by courtesy Christie's London

Figure 14. Robert Rauschenberg, *Erased de Kooning*, 1953
Traces of ink and crayon on paper, with mount and hand-lettered ink by Jasper Johns,
64.14 x 55.25 x 1.27cm
Photo: © by San Francisco Museum of Modern Art © Robert Rauschenberg/VAGA, New York
and DACS, London 2006

Figure 15. Yves Klein, *Blue Sponge Relief (RE 40)*, 1960
Sponges and dry pigment in synthetic resin on board (200 × 164.5 cm)
Photo: © David Woody © by courtesy of Art Institute of Chicago, Chicago

Figure 16. Anselm Kiefer's studio in Barjac
Photo: © the artist

Figure 17. Nam June Paik, *TV Buddha*, 1974
Video installation with bronze sculpture, Galeria Bonino, New York
© the artist

Figure 18. Nam June Paik, *Zen for Film*, 1962/4
Approximately 23 minutes of 16 mm film, Flux Hall, New York
© the artist

Figure 19. Nam June Paik, *Good Morning, Mr. Orwell*, 1984
International satellite installation, WNET TV in New York, the Centre Pompidou in Paris live via satellite with broadcasters in Germany and South Korea
© the artist

Figure 20. Rembrandt, *The Descent from the Cross*, 1634
Oil on wood, 89.4 × 65.2cm, Alte Pinachthek, Munich
Photo: © by Alte Pinakothek, Munich

Figure 21. Bill Viola, Installation view *Five angels for the Millennium*, 2001
i. "Departing Angel" ii. "Birth Angel" iii. "Fire Angel" iv. "Ascending Angel" v. "Creation Angel"
Five channels of color video projection on walls in large, dark room; stereo sound for each projection, Tate Modern, London
© the artist, Photo: © by Mike Bruce, courtesy of Anthony d'Offay, London

Figure 22. Bill Viola, *Stations*, 1994
Video/sound installation, 430 x 1460 x 1770 cm
Five channels of color video projections on five cloth screens, suspended from the ceiling of a large, darkened gallery; five slabs of black granite on floor in front of each screen; five channels of amplified mono sound
© the artist, Photo: © by Charles Duprat

Figure 23. Atta Kim, *ON-AIR Project #032: The Silk Road*, 2004
8-hour exposure, light jet C-print, 203 × 251cm
© the artist

Figure 24. Atta Kim, *ON-AIR Project #029: The Sex*, 2004
1-hour exposure, light jet C-print, 188 × 248cm
© the artist

Figure 25. Atta Kim, *ON-AIR project 047-1, 100 Men, the series Self-portrait*, 2004
233 × 188cm, ICP, New York
© the artist

Figure 26. Atta Kim, *ON-AIR project 047-2, 100 Men, the series Self-portrait*, 2004
multiple images in process of compiling Self-portrait, 233 × 188cm, ICP, New York
© the artist

Figure 27. Mariko Mori, *Dream Temple*, 1999
Metal, glass, plastic, fiber optics, fabric, vision dome (3-D hemispherical display), audio, 500
× 1000cm, Installation view at Royal Academy of Arts, London
© the artist, Photo: © by Richard Learoyd, courtesy Fondazione Prada, Milan

Figure 28. Mariko Mori, *Wave UFO*, 3-D Interactive installation, 2003
Acrylic, Carbon Fiber glass, Aluminum, TechnoGel® 4.93 × 11.35 × 5.28m, 500 × 1000cm,
Installation view at Victor Pinchuk Art Centre, Kyiv
© the artist, Photo: © by Sergiy Illin

Figure 29. Jungu Yoon, *Stroke*, 2005
four-piece digital prints on Korean paper, 30 × 40cm each, Triangle space, London
© the artist

Figure 30. Jungu Yoon, *In the temple*, 2007
Video projection on Acrylic sculpture, 30 × 20 × 20cm, Triangle space, London
© the artist

Figure 31. *Digital and Physical Surfaces* Exhibition, 2007
Triangle space, London
© the artist

Figure 32. Jungu Yoon, *Radiant*, 2008
Video projection on Copper sculpture.
© the artist

Figure 33. Jungu Yoon, *The Fall project*, 2008
Video/sound installation, OXO Bargehouse, London
© the artist, Photo: © by courtesy of 4482

Figure 34. Plan for *The Fall project*

Figure 35. Jungu Yoon, *Snow Project*, 2009
Video / Sound 1' 44' loop, KCC, London

Figure 36. Jungu Yoon, *Communion*, 2009
Wine drawing on paper / Performance documentation
Toronto University, Canada

Bibliography

ALTER, S. (2001) *Sacred Waters: a pilgrimage up the Ganges river to the source of Hindu culture*, New York, Harcourt.

ANDREW, E. (2005) *Writing the Sacred Journey: the art and practice of spiritual memoir*, Boston, Massachusetts and Enfield, Skinner House.

Anon. (1995) *Yves Klein now: sixteen views,* London, South Bank Centre.

ART GALLERY OF ONTARIO. (1969) *The sacred and profane in symbolist art*, Toronto.

ASHTON, D. (1964) *The unknown shore. A view of contemporary art.* [With reproductions.], pp. xviii. 265. Studio Vista: London; printed in U.S.A.

ASHTON, D. (1996) *About Rothko*, New York, Da Capo Press.

AVGITIDOU, A. (2003) *The artist as subject in creative stasis and drasis, explored through performative subjectivity in media art and diary practice.* [PhD thesis], London, London Institute.

BAAS, J. (2005) *Smile of the Buddha: eastern philosophy and western art from Monet to today*, Berkeley, California and London, University of California Press.

BARNES, S. J. (1989) *The Rothko chapel: an act of faith*, Houston, Texas, Rothko Chapel, Austin, University of Texas Press.

BAXENDALL, M. (1972) *Painting and experience in fifteenth century Italy*, Oxford, Oxford University Press.

BELLAH, R. N. (1976) *Beyond belief: essays on religion in a post-traditional world*, New York and London, Harper and Row.

BEUYS, J., KLEIN, Y. and ROTHKO, M. (1987) *Beuys, Klein, Rothko*, London, Anthony d'Offay Gallery.

BILLINGTON, R. (2002) *Religion without God*, London, Routledge.

BIOCCA, F. and LEVY, M. R. (1995) *Communication in the age of virtual reality*, Hillsdale and Hove, Lawrence Erlbaum.

BOIS, Y.-A. and R. E. KRAUSS (1997) *Formless* : a user's guide. New York, Zone Books.

BOYD, F. (1999) *New media culture in Europe: art, research, innovation, participation, public domain, learning, education, policy*, Amsterdam, Uitgeverij de Balie and the Virtual Platform.

BURCKHARDT, T. and NORTHBOURNE, W. E. C. J. B. (1976) *Sacred art in East and West: its principles and methods*, Bedfont, Perennial Books.

BURKE, E. and PHILLIPS, A. (1990) *A philosophical enquiry into the origin of our ideas of the sublime and beautiful*, Oxford, Oxford University Press.

CARROLL, N. L. and CARROLL, N. L. (1998) *A Philosophy of mass art*, Oxford, Clarendon Press.

CASEMENT, A. and TACEY, D. (2006) *The idea of the numinous: contemporary Jungian and psychoanalytic perspectives*, London, Routledge.

CASTANEDA, C. (1999) *The wheel of time*, London, Allen Lane.

CHRISTENSEN, C, C. (1967) *Municipal patronage and crisis of the arts in reformation Nuernberg, Church History Vol. 36(No. 2)*; pp.140-150

CHUN, W. H. K. and KEENAN, T. (2006) *New media, old media: a history and theory reader,* New York and London, Routledge.

COULDRY, N. and MCCARTHY, A. (2004) *MediaSpace: place, scale, and culture in a media age*, London, Routledge.

CRARY, J. (1990) *Techniques of the observer: on vision and modernity in the nineteenth century*, Cambridge, Massachusetts and London, MIT Press.

CROWTHER, P. (1989) *The Kantian sublime: from morality to art*, Oxford, Clarendon.

DARLEY, A. (2000) *Visual digital culture*, Routledge.

DAVID (1999) *'Public at last sees the art behind the fuss'*, The New York Times, New York.

DAVIDSON, G. (1967) *A Dictionary of angels; including the fallen angels*, Free Press, New York and London, Collier-Macmillan.

DECKER PHILLIPS, E. (1998) *Paik video, New York*, Barrytown, Ltd.

DERRIDA, J. and STIEGLER, B. (2002) *Echographies of television*: filmed interviews, Cambridge, Polity Press.

DEVEREUX, E. (2003) *Understanding the media*, London, SAGE.

DORMENT, R. (2003) *Damien bares his soul*. Daily Telegraph, London.

DRURY, J, M. (1999) *Painting the word; Christian pictures and their meaning*, New Haven, Connecticut and London, Yale University Press in association with National Gallery Publications.

DUNCAN, F. (2004) 'Historical and contemporary perspectives on the paradigm shift'. In: Anderson, G. *Reinventing the museum*, California and Oxford, AltaMira Press, p.11.

ELIADE, M. (1977) From primitives to zen: a thematic sourcebook of the history of religions, [S.I.], Fount Pubs.

ELIADE, M. (1978) *A history of religious ideas*, Chicago, University of Chicago Press.

ELIADE, M. (1987) *The encyclopedia of religion*, London, Macmillan.

ELIADE, M. and PHILIP, M. (1960) *Myths, dreams, and mysteries: the encounter between contemporary faiths and archaic realities*, [S.I.], Harvill.

ELIADE, M. and TRASK, W. R. (1959) *Sacred and the profane: nature of religion*, [S.I.], Harcourt Brace.

ELIADE, M. E. (1959/1974)*The History of Religions: Essays in Methodology*, [S.I.]: University of Chicago.

FARROW, C. and W. LAIB (1996) *Wolfgang Laib: a journey*. Ostfildern-Ruit, Cantz.

FREUD, S. and D. MCLINTOCK (2003) *The uncanny*. London, Penguin.

GAMWELL, L. (2002) *Exploring the Invisible: art, science, and the spiritual*, Princeton, New Jersey and Oxford, Princeton University Press.

GARRAND, T. P. (2001) *Writing for multimedia and the web*, Boston and Oxford, Focal.

GERE, C. (2002) *Digital culture*, London, Reaktion.

GOMBRICH, E. H. (1989) *The story of art,* Oxford, Phaidon.

GRAU, O. (2003) *Virtual Art: from illusion to immersion*, Cambridge, Massachusetts and London, MIT.

HALL, B. and JASPER, D. (2003) *Art and the spiritual*, Sunderland, University of Sunderland Press.

HANHARDT, J. G. (2000) *The worlds of Nam June Paik*, New York, Guggenheim Museum.

HANSEN, M. B. N. (2004) *New philosophy for new media*, Cambridge, Massachusetts and London, MIT Press.

HASUMI, T. (1962) *Zen in Japanese art: a way of spiritual experience*, Routledge and Kegan Paul.

HEIM, M. (1998) *Virtual realism*, New York and Oxford, Oxford University Press.

HIRST, D. and HIRST, D. R. I. T. A. O. U. (2003) *The cancer chronicles*, London, Other Criteria.

HOGG, A. (1997) *Bill Hall interview*. Edinburgh, Fruitmarket gallery.

HOLLAND, C. H. (1999) *The idea of time*, Chichester, Wiley.

HOOPER GREENHILL, E. (1995) *Museum, media, message*, London, Routledge.

HORNBY, A. S., ASHBY, M. and WEHMEIER, S. (2000) *Oxford advanced learner's dictionary of current English*, Oxford, Oxford University Press.

HUMPHREYS, C. (1961) *Zen Buddhism*, [S.l.], Unwin Books.

HYUNG YUL, W. (2003) *Study of 'Shinsa' in oriental painting on Song dynasty painting*. [PhD thesis], Seoul, Hongik University.

INTERFAX (2007) Ukraine's orthodox believers demand to close an exhibition insulting Christian feelings.

JOHN PAUL II, P. (1981) *Love and responsibility*, London, Collins and Fount, 1982.

JOHNSTON, W. (1978) *The inner eye of love: mysticism and religion*, London, Collins.

JUNG, C. G. (1953) *The collected works of C.G. Jung, vol 11, 7*., ed. William McGuire et al., trans. R. F. C. Hull, Bollingen Series XX, Princeton, N.J., Princeton University Press.

JUNG, C. G. (1968) *The archetypes of the collective unconscious, second edition. Vol 9, Part 1. Collected Works*, (transl. R. F. C. Hull), London, Routledge and Kegan Paul.

JUNG, C. G. (1969) *The structure and dynamics of the psyche, second edition. Vol 8. Collected Works* (transl. R. F. C. Hull), London, Routledge and Kegan Paul.

JUNG, C. G. (1993) *Memories, dreams, reflections*, A. Jaffé (ed.), London, Fontana.

KANDINSKY, W. and SADLER, M. T. H. (1977) *Concerning the spiritual in art*, New York, Dover Publications and London, Constable.

KIEFER, A. and M. AUPING (2005) Anselm Kiefer: *heaven and earth*. Munich; London, Prestel.

KIM, A. (2006) Atta Kim: *On-air*, New York, International Center of Photography.

KIM, A. (2007) *Atta Kim's monologue*. Seoul, Wisdom house.

KIM, A. and KIM, Y. Y. (2005) *The museum project*, New York, Aperture.

KIM, H. H. I. *Paik Nam June*, Seoul, Dijain Hausu

LAOZI (1991) *Further teachings of Lao-tzu: understanding the mysteries*: a translation of the

Taoist classic Wen-tzu, Shambhala.

LAOZI and HAMILL, S. (2005) *Tao te ching*, Boston, Massachusetts and London, Shambhala.

LEE, Y. W. (2000) *Nam June Paik; life and art*, Seoul, Yulumsa.

LEEUW, G. V. D. (1967) *Religion in essence and manifestation*, Gloucester and Massachusetts, Smith.

LEEUW, G. V. D. and GREEN, D. E. (1963) *Sacred and profane beauty: the holy in art*, [S.l.], Weidenfeld and Nicolson.

LEWIS, C. S. (1940) *the problem of pain*, [S.l.], Bles: The Centenary Press.

LYONS, J. and PLUNKETT, J. (2007) *Multimedia histories: from the magic lantern to the internet*, Exeter, University of Exeter Press.

MANOVICH, L. (2001) *The language of new media*, Cambridge, Massachusetts and London, MIT Press.

MASPERO, H. (1981) *Taoism and Chinese religion*, Amherst, Massachusetts University Press.

MAYER, M. (1996) *Being and time: the emergence of video projection*, Buffalo, New York, Buffalo Fine Arts Academy.

MCGLOUGHLIN, S. (2001) *Multimedia: concepts and practice*, Upper Saddle River, New Jersey, Prentice Hall.

MONACO, J. (2000) *How to read a film: the world of movies, media, and multimedia: language, history, theory*, New York and Oxford, Oxford University Press.

MOORE, L. E. (1990) *Beautiful sublime: the making of Paradise Lost,* 1701-1734, Stanford, California, Stanford University Press.

MUIR, G., HIRST, D., LUCAS, S., FAIRHURST, A., MUIR, G. and WALLIS, C. (2004) *In-a-Gadda-da-Vida*: Angus Fairhurst, Damien Hirst. Sarah Lucas, London, Tate.

NORMAN, J. and A. WELCHMAN (2004) *The new Schelling*. New York; London, Continuum.

OTTO, R. and HARVEY, J. W. (1959) *The idea of the holy; an inquiry into the non-rational factor in the idea of the divine and its relation to the rational,* Translated by John W. Harvey, Penguin Books: Harmondsworth.

PACKER, R. and JORDAN, K. (2002) *Multimedia: from Wagner to virtual reality,* New York and London, Norton.

PAIK, N. J. and HANHARDT, J. G. (1982) *Nam June Paik,* New York and London, Whitney Museum of American Art, New York in association with W.W. Norton.

PARK, S. G. (1999) *Theory of Chinese landscape painting*, Seoul, Shin Won Press.

REEVE, J., ARMSTRONG, K., FOX, E., PETERS, F. E. and BAKER, C. F. (2007) *Sacred: books of the three faiths: Judaism, Christianity, Islam,* London, British Library.

ROTHKO, M. and B. CLEARWATER (1984) *Mark Rothko,* works on paper. Oxford, Phaidon, 1989.

ROWLEY, G. (1959) *Principles of Chinese painting*, Princeton, Princeton University Press.

RUSH, M. (1999) *New media in late 20th-century art*, London, Thames and Hudson.

SCHELLING, F. W. J. v. (2007) *Historical-critical introduction to the philosophy of mythology.* Albany, State University of New York Press.

SCHELLING, F. W. J. v. and V. Hayes (1995) *Schelling's philosophy of mythology and revela-tion*: three of seven books. Armidale, N.S.W., Australian Association for the Study of Religions: x, 382p.

SERRES, M. (1995) *Angels; a modern myth*, Paris, Flammarion.

SIREN, O. (1925) *Chinese sculpture from the fifth to the fourteenth century. Over 900 specimens in stone, bronze, lacquer and wood, principally from Northern China with descriptions and an introductory essay, 4 vol.* pp. clii. 168. pl. 623. Ernest Benn, London.

SMART, N. (1995) *Worldviews: crosscultural explorations of human beliefs,* Englewood Cliffs, New Jersey, Prentice Hall and London, Prentice Hall International.

SPIELMANN, Y. (2008) Video: *the reflexive medium*, Cambridge, Massachusetts and London, MIT.

STRACHAN, I. (2000) *Virtual reality and simulation: technology, trends and markets*, Coulsdon, Jane's Information Group.

SYKES, J. B. (1982) *The concise Oxford dictionary of current English: based on the Oxford English Dictionary and its supplements*, Oxford, Clarendon.

SYLVESTER, D. and F. Bacon (1975) *Interview with Francis Bacon*, London, Thames and Hudson.

TATE, G., NEWMAN, B. and HESS, T. B. (1972) *Barnett Newman*: [catalogue of an exhibition held at] the Tate Gallery, 28 June-6th August 1972; [and, an introductory essay], London, Tate Gallery.

TAYLOR, J. A. (1999) *Koans of silence: the teaching not taught, Vol 24, no 2*, Parabola.

TOMAS, D. (2004) *Beyond the image machine: a history of visual technologies*, London, Continuum.

TRIBE, M. and R. JANA (2006). *New media art*, Köln and London, Taschen.

TUCHMAN, M., FREEMAN, J. and BLOTKAMP, C. (1986) *The spiritual in art: abstract painting 1890-1985,* New York, Abbeville Press.
VIDLER, A. et al. (2007) Antony Gormley : blind light. London, Hayward Gallery.

VIOLA, B., SELLARS, P., WALSH, J. and BELTING, H. (2003) *Bill Viola: the passions*, Los Angeles and London, J. Paul Getty Museum in association with the National Gallery, London.

VIOLA, B. and SPARROW, F. E. (1996) *Bill Viola: the messenger,* Chaplaincy to the Arts and Recreation in North East England.

VIOLA, B. and VIOLETTE, R. (1995) *Reasons for knocking at an empty house: writings 1973-1994*, Cambridge, Massachusetts, MIT Press and London, Anthony d'Offay Gallery.

WARNER, M. (1996) *The inner eye: art beyond the visible*, [Great Britain], National Touring Exhibitions, Manchester, Cornerhouse [distributor].

WILLIAMS, B. A. O. and NAUCKHOFF, J. (2001) *Nietzsche: the gay science*, Cambridge, Cambridge University Press.

WILLIAMSON, B. (2004) *Christian art: a very short introduction*, Oxford, Oxford University Press.

YOON, Y. H. (2003) *Sacred and contemporary art*, Busan, Kosin University Press.

ZIA, P. (2001) *Poetic anatomy of the numinous: creative passages into the self as beloved*. Plymouth, University of Plymouth.

ZURBRUGG, N. (2004) *Art, performance, media: 31 interviews*, Minneapolis, Minnesota and London, University of Minnesota Press.

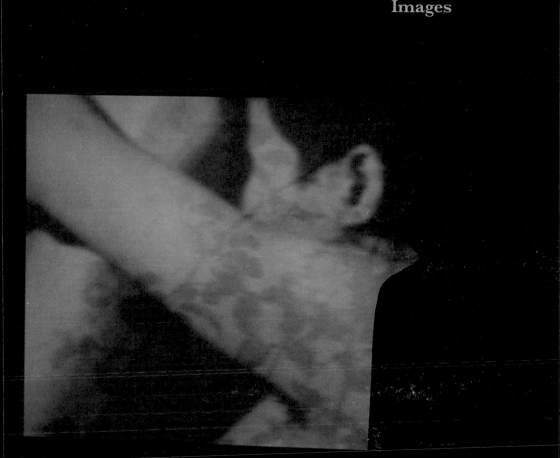

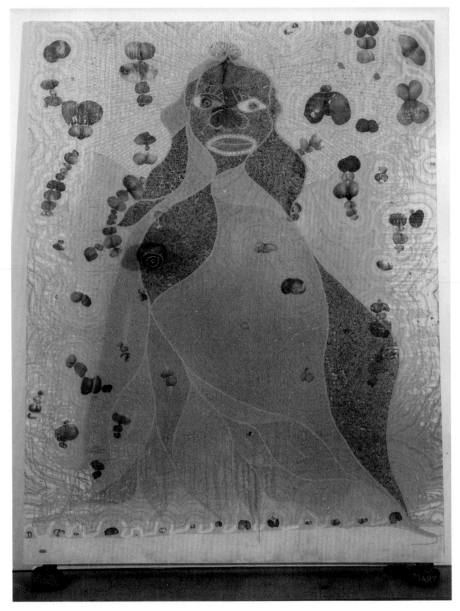

Figure 4. Chris Ofili, 1996, *The Holy Virgin Mary.*

Figure 5. Andres Serrano, 1987, *Piss Christ*.

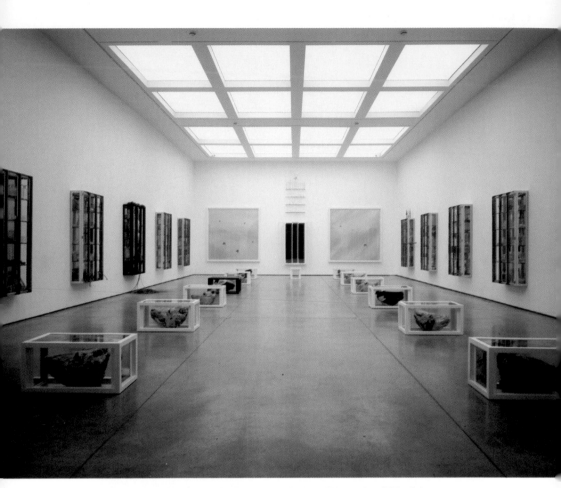

Figure 7. Damien Hirst, 2003, *Romance in the Age of Uncertainty*, White Cube

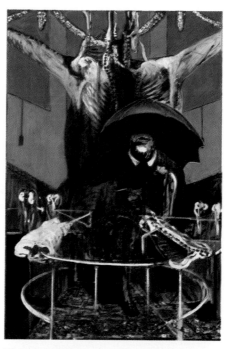

Figure 9. Francis Bacon, 1946, *Painting*.

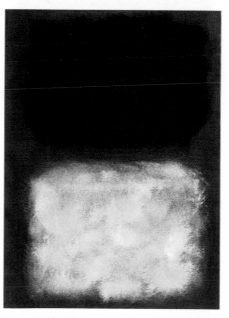

Figure 13. Mark Rothko, 1963, *Black, White, Blue*.

Figure 15. Yves Klein, 1960, *Blue Sponge Relief (RE 40)*.

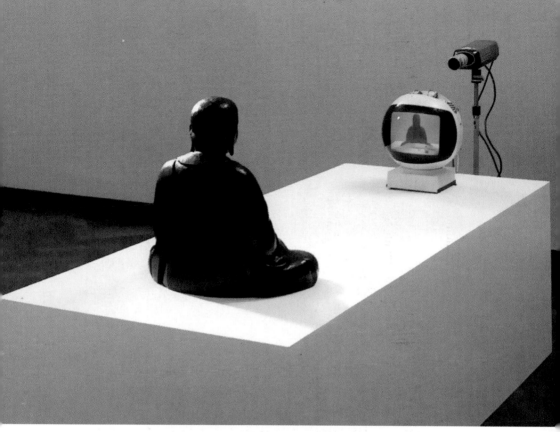

Figure 17. Nam June Paik, 1974, *TV Buddha*,
Video installation with bronze sculpture, Galeria Bonino, New York.

Figure 19. Nam June Paik, 1984, *Good Morning, Mr.
Orwell,* International satellite installation,
WNET TV in New York, the Centre Pompidou in Paris
live via satellite with broadcasters in Germany and
South Korea.

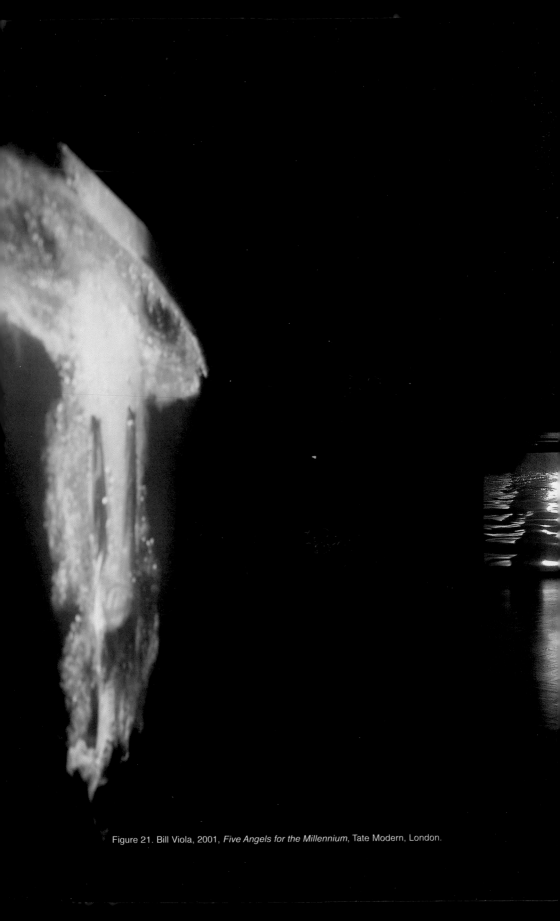

Figure 21. Bill Viola, 2001, *Five Angels for the Millennium*, Tate Modern, London.

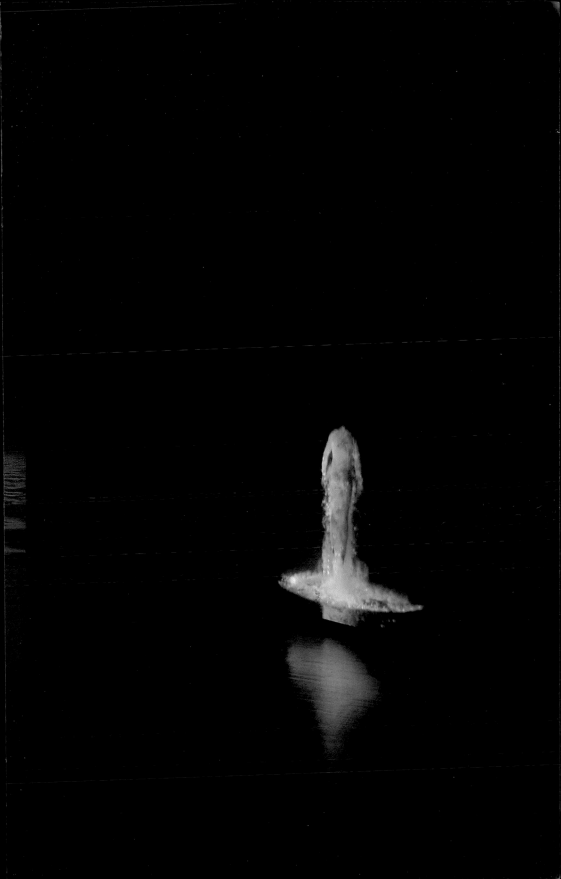

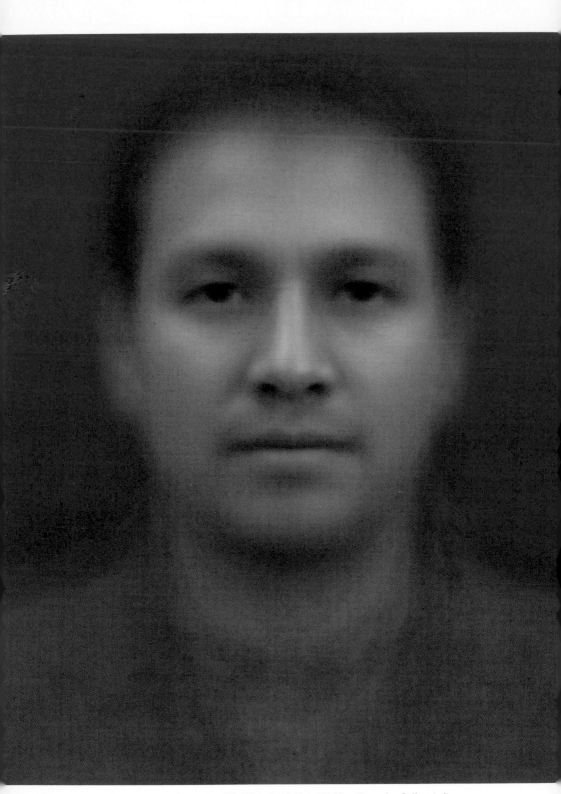

Figure 25. Atta Kim, 2004, *ON-AIR project 047-1, 100 Men, the series Self-portrait.*

Figure 26. Atta Kim, 2004, *ON-AIR project 047-2, 100 Men, the series Self-portrait.*

Figure 27. Mariko Mori, 1999, *Dream Temple*, Installation view at Royal Academy of Arts. London.

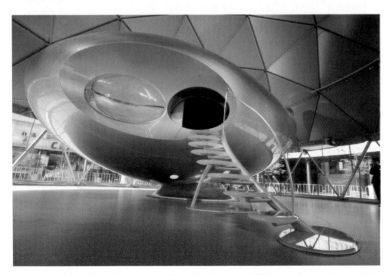

Figure 28. Mariko Mori, 2003, *Wave UFO*, Installation view at Victor Pinchuk Art Centre, Kyiv.

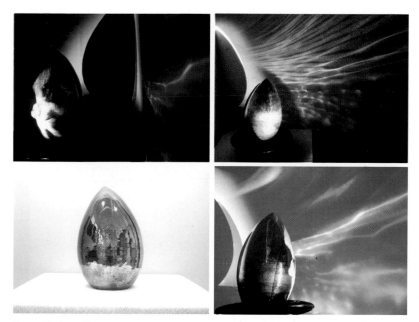

Figure 32. Jungu Yoon, 2008, *Radiant*.

Figure 35. Jungu Yoon, 2009, *Snow Project*, KCC, London.

Figure 36. Jungu Yoon, 2009, *Communion*, Canada.

Jungu Yoon is a researcher at FADE within the International Centre for Fine Art Research. He was born in South Korea and now lives and works in London. This provides him with a cosmopolitain viewpoint across both Eastern and Western cultures.